CHATHAM
THROUGH TIME

From Fishing Village to Seaside Destination

Janet M. Daly

JANET M. DALY

AMERICA
THROUGH TIME®
ADDING COLOR TO AMERICAN HISTORY

To my brother, Bill Russell, who introduced me to the charms of Chatham, and to the other people of Chatham—past, present, and future—who foster community through religious, civic, and charitable organizations. God bless!

TOWN PICTURE A FIRST NIGHT TRADITION: The initial snowy First Night eve was 1996-1997. Sunshine usually prevails, though it can be chilly at the lighthouse, as in 2015-2016. (Photos: First Night Chatham and Brandon DeTraglia)

BACK COVER: Photos courtesy of Chatham Historical Society.

America Through Time is an imprint of Fonthill Media LLC
www.through-time.com
office@through-time.com

Published by Arcadia Publishing by arrangement with Fonthill Media LLC
For all general information, please contact Arcadia Publishing:
Telephone: 843-853-2070
Fax: 843-853-0044
E-mail: sales@arcadiapublishing.com
For customer service and orders:
Toll-Free 1-888-313-2665

www.arcadiapublishing.com

First published 2017

Copyright © Janet M. Daly 2017

ISBN 978-1-63500-053-5

Typeset in Mrs Eaves XL Serif Narrow
Printed and bound by CPI Group (UK) Ltd, Croydon, CR0 4YY

INTRODUCTION

In 2007, The National Trust for Historical Preservation selected Chatham as one of its twelve Distinctive Destinations Award recipients. Chatham was the first town on Cape Cod to receive the award, and only the fourth in the Commonwealth of Massachusetts. The reason for the award was based on the preservation of historic landmarks, revitalization of the downtown, and the protection of the unique heritage of Chatham.

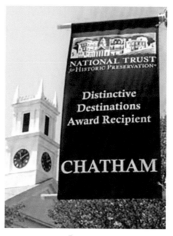

Centuries before the award, William Nickerson, the founder of Chatham, had decided in 1664 that he was willing to break some Massachusetts Bay Colony rules to make what was then called Monomoit (by the Native Americans who lived there) his home. William wasn't interested in preserving history; he was interested in making history. The destination he sought for his home was rich in natural resources on land and in the sea, was set off from the rest of the colony, and was the first stop of the East Wind.

Ever since William made his mark, fishermen, merchants, clergy, artisans, sportsmen, royalty, vacationers, and more recently retirees have found Chatham the ideal destination for their hopes and dreams. In the 19th century, in the Age of Sail, Chatham was the home of the finest sea captains on the East Coast. Most of them were born there, where going to sea was a way of life. Great efforts were made to honor these seafaring men as well as preserve their heritage and homes.

In the 20th century, the attractive location, milder winters, and lively downtown attracted retirees in large numbers to Chatham. Retirees brought life experience and knowledge, and took part in the civic life of the community.

The younger generation also found Chatham a great place to live. Whether they were from a family of fishermen, wanted to open a boutique or studio, needed a place

to express their art, or wanted to bring up children in a small town, Chatham offered opportunity.

Beaches, restaurants, night spots, fine hotels and inns, musicians of all persuasions, and a lively theater arts scene bring vacationers from around the world to Chatham, where they are warmly welcomed.

Family life and fun is also important to residents. The Fourth of July Parade and First Night Chatham may be the biggest events of the year; however, there are many other events that take place. For example, at Kate Gould Park you can find pumpkin people in the fall, Christmas trees in the winter, and Sharks in the Park in the summer. The Congregational Church has a pumpkin patch right before Halloween, and is the site of the crèche at Christmas. The Methodist Church feeds concert and parade goers.

Past and present residents of Chatham have reason to be proud of their town, its people, and its history. They want to ensure that its culture and heritage is there for the future, so they value the historic landmarks, enjoy the vital downtown, and respect their past. It is no mystery why visitors and summer residents are drawn to Chatham.

CONTENTS

CHATHAM'S SEAL: Adopted in 1962, the seal illustrates the seafaring
vessels, twin lights, and ubiquitous cod for which the cape is named.

Acknowledgements

I appreciate the support of Danielle Jeanloz, executive director of the Chatham Historical Society. My sincere thanks to Jean Young and Judy Conniff for their unswerving availability and assistance in researching this book. And to all the volunteers at the Atwood House Museum, many thanks for preserving Chatham's history.

I am most grateful for the photographers who have been so considerate and cooperative in allowing me to use their work, and the organizations as well. They enrich this book for our readers.

1

A SEAFARING VILLAGE

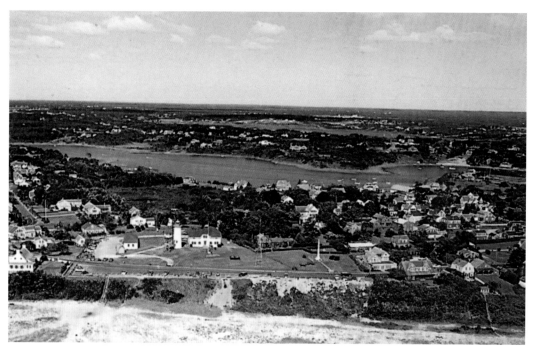

WATER, WATER, EVERYWHERE: Chatham's location, surrounded by sea and dotted with rivers and ponds, sealed its destiny as both a seafaring village and a seaside resort. In the mid-1920s, Chatham Light, the overlook, and Lighthouse Beach rose above the Atlantic Ocean (not visible) spilling into Aunt Lydia's Cove and Pleasant Bay beyond. (Photo: Chatham Historical Society)

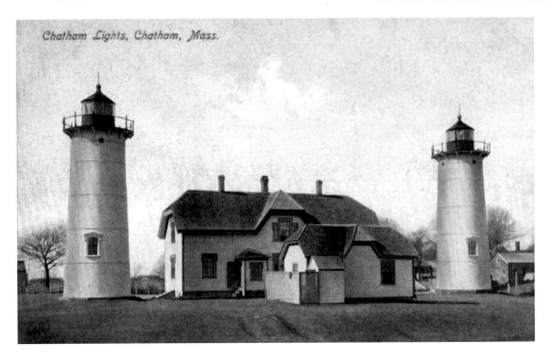

TWIN LIGHTS CHATHAM: Prior to 1923, the Chatham Lighthouse was known as Cape Cod's Twin Lights. Because of dangerous shoals and sand bars, the first lighthouse was built in 1808. It had two towers to distinguish it from Highland Light, the first Cape Cod beacon. In 1923, the northern tower was moved roughly twelve miles to become Nauset Light. Technology then made it possible to use a double-flash automated beacon so ships could tell the two lights apart. Today, the Chatham Light continues to be a beacon in good weather and bad. Located on the elbow of Cape Cod, Chatham catches many ocean storms and some misty conditions. (Top photo: Chatham Historical Society)

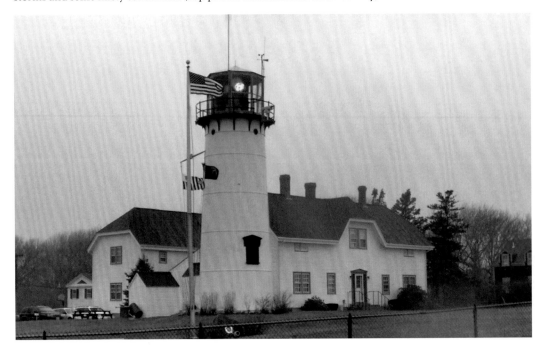

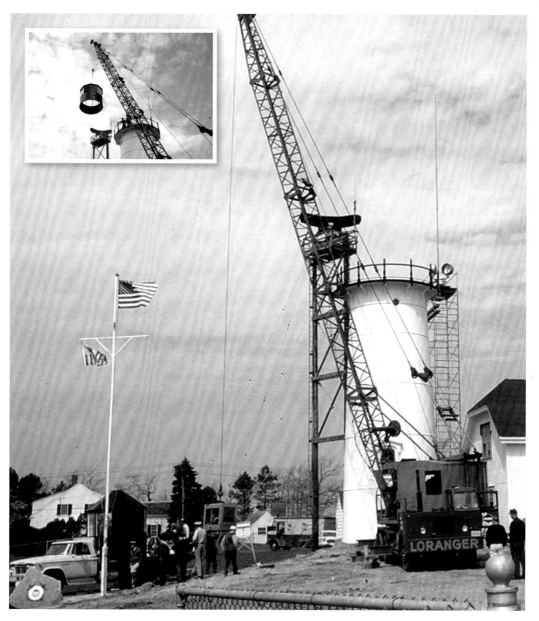

THE BEACON GETS REPLACED: In 1969, the Fresnel lens that had been Chatham's "light" for over 30 years was replaced by a Carlisle & Finch DCB-224 rotating light generating over 2.8 million candlepower. The light was automated in 1982 and a directional circulating beam was installed in 1993. The replacement of the turret was a major feat, as can be seen from the use of a crane. The Fresnel lens is made up of a number of lenses, and moving it from inside the turret from such a height required precision and skill. That's a radar tower directly behind the turret. (Photos: Chatham Historical Society)

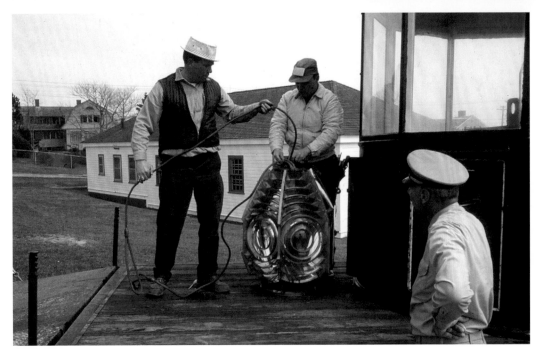

TREASURING THE TURRET: Recognizing the historic nature of the Fresnel lens and its vintage turret, the Coast Guard donated it to the Chatham Historical Society, where it now rests on the Atwood House Museum grounds honoring Fannie Lewis Shattuck, who was instrumental in its presentation to the society and was responsible for its move there. Several years ago, the Fresnel lens was completely refurbished and placed on a pedestal so visitors to the museum may walk up to the light and view it up close. (Top photo: Chatham Historical Society)

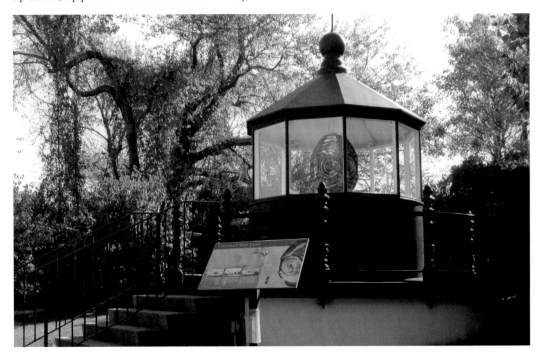

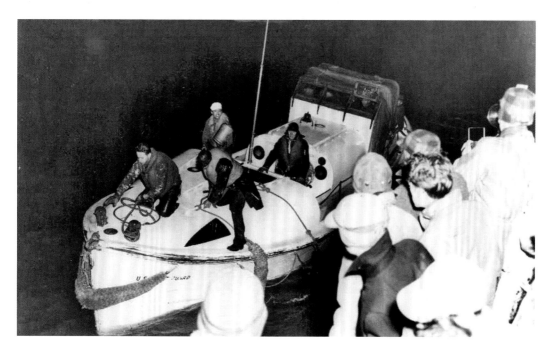

COAST GUARD STATION CHATHAM: Today, the former lighthouse keeper's house is an active multi-mission Surf Station. Search and Rescue, maritime law enforcement, and Homeland Security missions are performed from Chatham. Flotilla 11-01 of the Coast Guard Auxiliary operates from the station. Boats for the mission are kept at the Chatham Fishing Pier on Chatham Harbor and at Stage Harbor. The 1952 heroic rescue, shown above, of the tanker *Pendleton's* crew, made famous in *The Finest Hours* movie, was the work of this station. In 2009, the 44-foot motor launch CG44301 was retired to the front lawn of the station, which had the distinction to maintain both the first and last of these lifeboats. (Top photo: Chatham Historical Society)

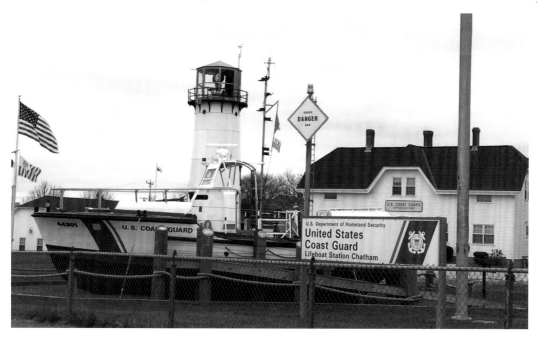

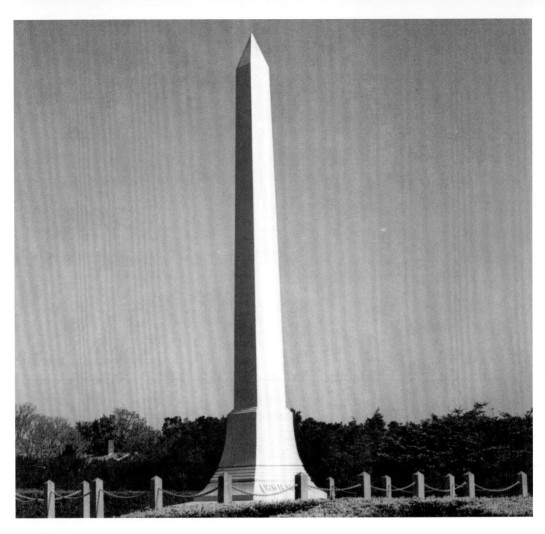

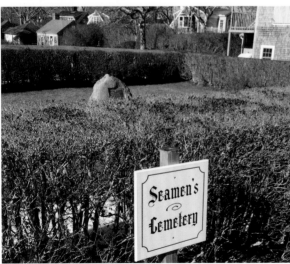

THE MACK MEMORIAL: Fifty years before the wreck of the *Pendleton*, on March 16, 1902, the *Wadena's* owner, William Henry Mack, and eleven other men—crew and lifesavers—drowned during their rescue from a storm. In 1908, Mack's mother had the obelisk erected next to the lighthouse in memory of her son and the others lost that day. Behind the monument is a cemetery for other men lost at sea, unidentified, but also victims of the treacherous sandbars that run beyond the coastline for miles. Hundreds of ships have met their fate along this coast. (Top photo: Chatham Historical Society)

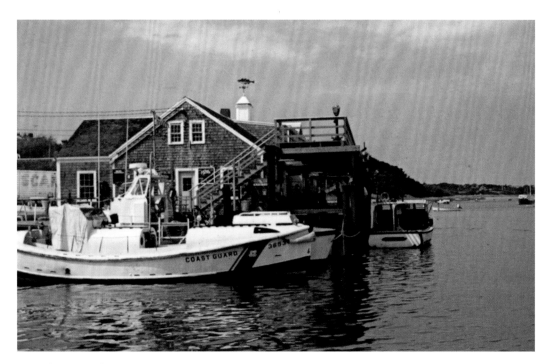

CHATHAM'S FISHING PIER: The Coast Guard has kept its boats at the Fishing Pier off Shore Road for many years. Before the old fish pier was remodeled—it is continually being updated and maintained by the town—the slips for the Coast Guard boats were on the south side of the packing plant. When the viewing deck for tourists to watch the fishing boats unload their catches was remodeled, and the stairs to it moved to the other side of the pier, the Coast Guard moved its whole new generation of surf and rescue vessels to slips on the other side as well. (Top photo: Chatham Historical Society)

AUNT LYDIA'S COVE: The fleet, on good days, may go to fishing grounds just offshore or up to 100 miles from Chatham. The fresh fish is processed and transported to New York, Boston, New Bedford, and local markets the same day caught. In addition to the pier and processing plant, there is a seasonal fish store. Gulls and seals congregate where the boats unload, looking for snacks. Tourists also flock to the fish pier to watch the unloading, and in season, there are guides for their information. (Bottom photo: David Hills, www.FishyPictures.com)

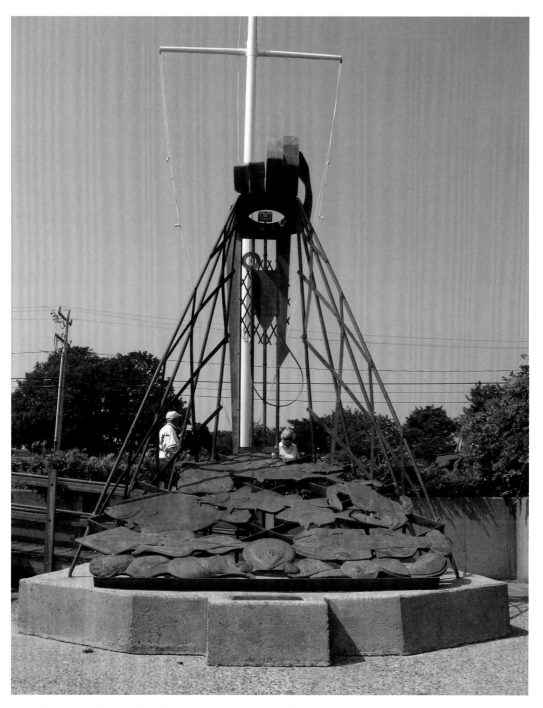

HONORING THOSE WHO GO DOWN TO THE SEA IN SHIPS: "The Provider" is the name of the monument at the Chatham Fish Pier that honors the past, present, and future independent men and women who go fishing from small boats. Sig Purwin was the artist and sculptor who won an international competition held back in 1992. Sig was from Cape Cod, working out of Woods Hole. The sculpture is a net filled with all the types of fish of the area, caught up by a giant hand. The plaque notes: "The Chatham Fishing Industry: Ever Changing to Remain the Same." (Photo: Sig Purwin Archive)

EVER CHANGING TO REMAIN THE SAME: The Chatham fishing fleet is made up of independent fishermen, many operating family-owned fishing businesses that have been passed on from father to son. In 1991, regulations were threatening the future of the local fleet. These fishermen came together to advocate at the highest levels. That is how the Cape Cod Commercial Fishermen's Alliance began. Today, this nonprofit seeks to preserve a healthy marine environment to ensure future generations of both fish and fishermen. Their reverence for the past extends to their headquarters located in the restored Harding House in West Chatham, saved from demolition by a concerned citizens group. (Bottom photo: Chatham Historical Society)

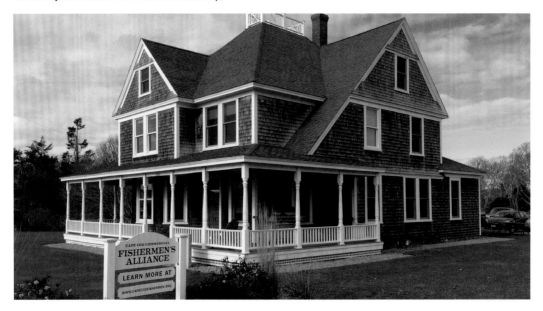

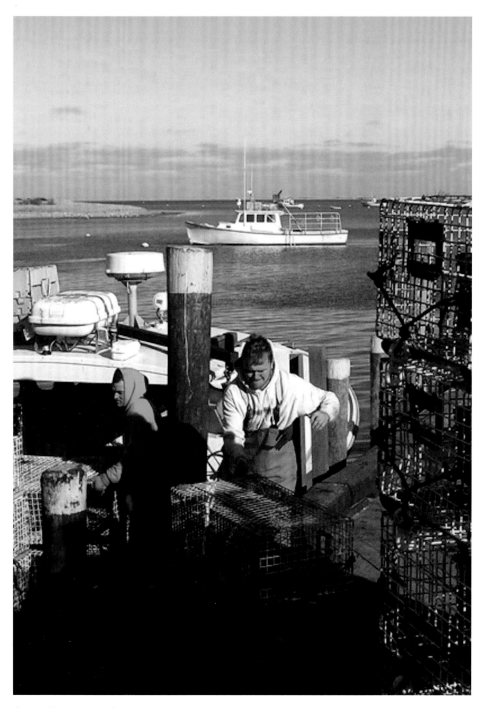

SMALL BOATS, BIG SALES: The members of the alliance are small-scale, independent Cape Cod fishermen, most operating family-owned fishing businesses. These day-boat fishermen represent an important part of the local economy. In 2015, they brought in some 12 million pounds of seafood, worth $16 million. Their catch can consist of black sea bass, bluefin tuna, bluefish, cod, dogfish, monkfish, skate, striped bass, as well as shellfish including lobsters, bay and sea scallops, mussels, and conch. (Photos: Courtesy of www.capecodfishermen.org)

THE SAIL LOFT: When the Sail Loft was constructed in 1858, Bridge Street and the Mitchell River Drawbridge were busy areas as the maritime industry flourished. Sailing vessels and commercial fishing boats need access to the river and Stage Harbor, so the location was ideal to service the mariners. Over the years, the building has had many uses, including the manufacture of sails, a boarding house, a studio for the marine architect Spaulding Dunbar, and a clothing store, as shown above. In later years, a local architect restored the building to a year-round residence preserving the original pine floors. (Top photo: Chatham Historical Society)

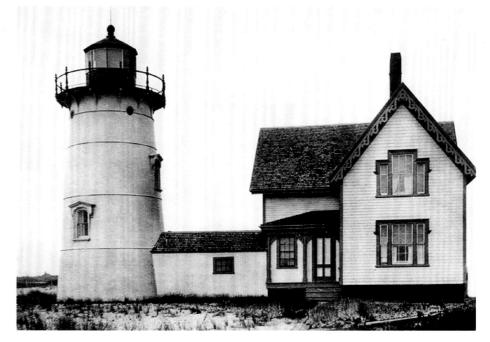

STAGE HARBOR LIGHTHOUSE: Built in 1880, the Stage Harbor Lighthouse, locally often referred to as Harding Beach Light, was built at the entrance to the harbor as an extra navigation aid. Records show that a light was needed at the entrance to Stage Harbor with a good range. A wood frame keeper's house and a 48-foot tower with a Fresnel lens was built on Hardings Beach. The first keeper was Enoch Eldredge. An automated light replaced the lighthouse. The lantern room was removed, and the tower was capped. The lighthouse and accompanying three acres was sold in 1936 to Henry Sears Hoyt, and remains in the Hoyt family. (Photos: Chatham Historical Society)

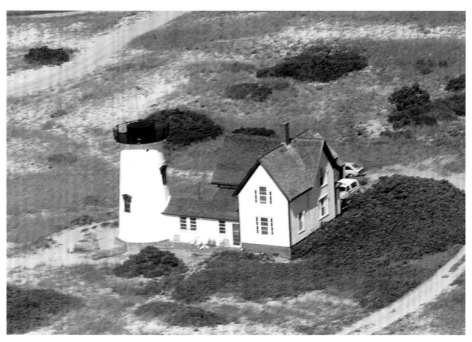

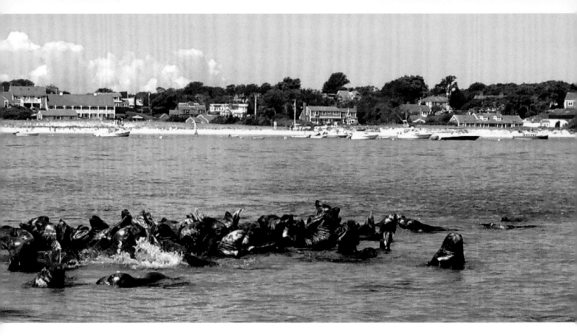

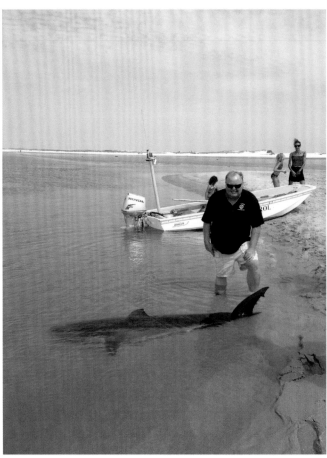

FIRST CAME THE SEALS, THEN THE SHARKS: On Cape Cod, it seems, where there are fish, there are seals. One tourist website lists the Chatham Fish Pier and nearby Chatham Harbor as the best place to see seals. Not just single seals that wait for droppings at the fish pier, but herds of them sunning themselves on the outcroppings of the barrier beach facing Lighthouse Beach. So many seals frolic in Chatham Harbor and along Monomoy Island that sharks follow the herd to feed. Harbormaster Stuart Smith rescued this small, stranded shark in 2015. However, the Atlantic White Shark Conservancy has tagged over two dozen great whites off Chatham to date. (Top photo: Jonathan Hochman; Bottom photo: Jason Holm)

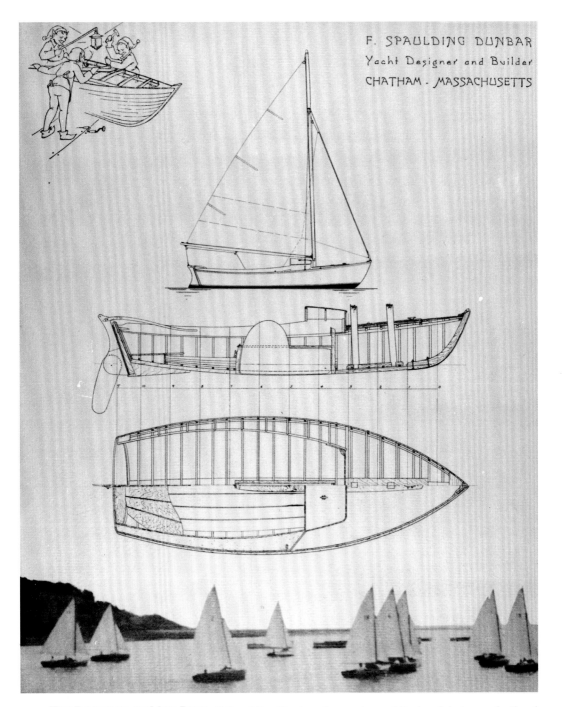

F. SPAULDING DUNBAR
Yacht Designer and Builder
CHATHAM - MASSACHUSETTS

THE BOATYARD ON MILL POND: F. Spaulding Dunbar, the marine architect and designer of sail and power boats, was the founder of the Mill Pond Boat Yard off Eliphamets Way in 1938. Prior to that, Dunbar had first set up shop at the Sail Loft property on Bridge Street and it was there he designed the Catabout for the Stage Harbor Yacht Club, for local water conditions. He then moved to what is now the Pease Boatworks and Marine Railway. The design of the Catabout is superimposed over actual boats under sail. (Photo: Chatham Historical Society)

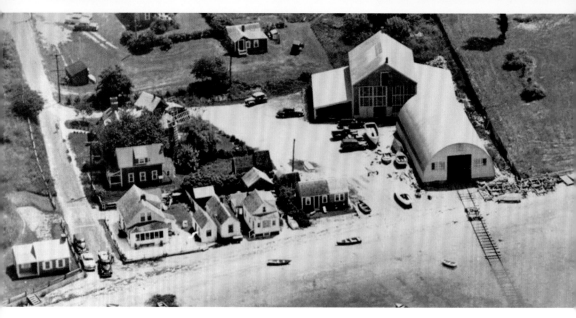

THE BOAT BUILDERS: The seafaring village of Chatham has been home since the 1980s to Pease Boatworks & Marine Railway. Internationally known wooden boat builders, the Pease brothers service boats of all kinds, yet the wooden boat tradition remains their major focus. Located on Mill Pond with access to Nantucket Sound through Stage Harbor, the yard has a long history. The boatyard was founded by the noted naval architect F. Spaulding Dunbar, who in the 1930s built the main structure from parts of the World War I blimp hangar at the Chatham Naval Air Station. Dunbar also built a Quonset hut on the site covering the marine railway following World War II. (Top photo: Chatham Historical Society)

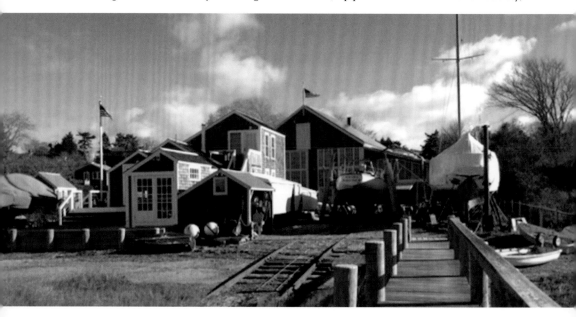

2

A Meandering Main Street

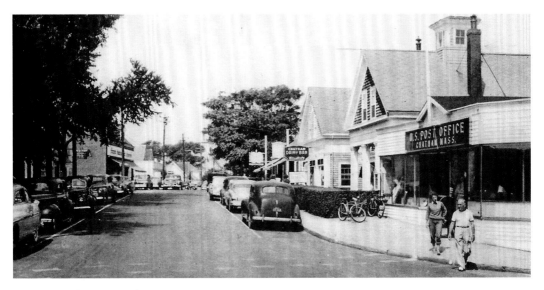

MAIN STREET IN CHATHAM: There is a town center in Chatham, and over the past 100 years downtown Main Street has been the heart of the community. Time does cause changes. The small town Main Street of the 1940s with a post office, First National grocery store, and ice cream shop has given way to upscale boutiques, inns, and eateries reflecting the shift to seaside resort from seafaring village. The post offices and grocery stores have moved to less expensive real estate down the road. (Photo: Chatham Historical Society)

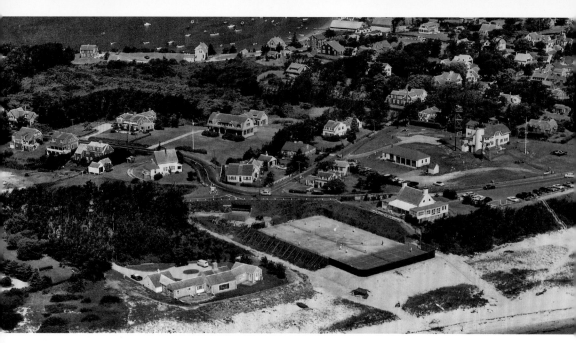

THE OLD VILLAGE HISTORIC DISTRICT: Listed on the National Register of Historic Places in 2001, the Old Village Historic District is bound by Main Street and Holway Street to the north, Bridge Street and Bearse's Lane to the south, Chatham Harbor to the east, and Mill Pond and Little Mill Pond to the west. The district contains a cross section of architecture, with houses dating from circa 1870 to the present. At the beginning of Main Street is the Mallows/Tarbell House, circa 1815, seen below and in the aerial view above. It was moved across the street from its original location, where the Chatham Beach and Tennis Club now stands on the bluff. Tennis courts in the aerial photo are just below the clubhouse. (Photos: Chatham Historical Society)

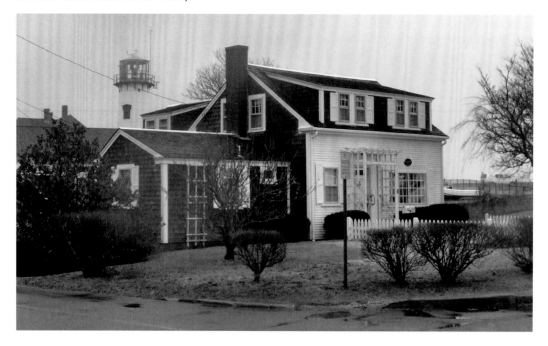

On the Other Side of Main Street: Built in 1929 in a silver leaf grove atop James Head bluff, the Chatham Beach and Tennis Club was designed by architect Edward Sears Read. Shortly thereafter, a footbridge to the beach was built, followed by the tennis courts. At that time, there was a marshy tidal lagoon at the foot of the bluff. The ever-changing coastline has most recently created a large tombolo that connects to Monomoy Island. Walking just up Main Street from the clubhouse, one arrives at the lookout across from Chatham Light. In good weather, but mostly after bad, this is the place to see how wind and storms constantly reshape the barrier beaches and shoreline.

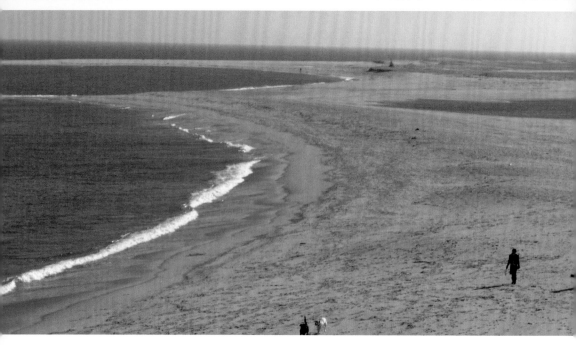

LIGHTHOUSE BEACH AND BEYOND: While the majority of visitors remain at the lookout, especially in cooler weather, there are always hardy souls who walk the beach with their dogs. The tombolo that now connects Monomoy Island with the mainland emerged in the early 2000s due to wind and water. The "cut," a breach in the barrier island that is now the entrance for the fishing pier and beyond, keeps changing. Sailors are warned about using the cut and crossing the sandbars. Local knowledge of the waters is stressed because it can be treacherous. The fishing boat in the photo below has navigated "crossing the bar" and is heading for the fish pier.

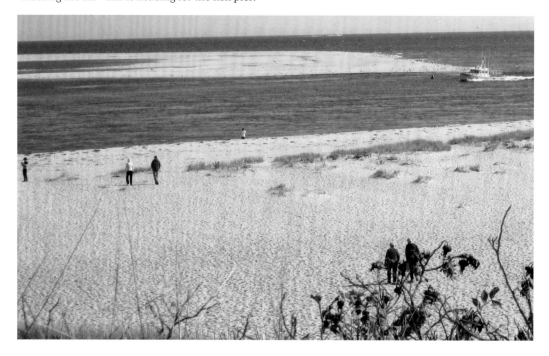

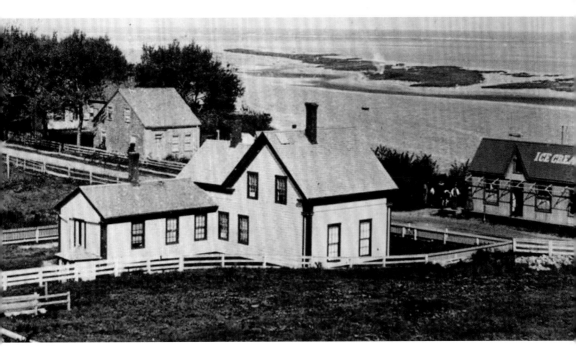

A VIEW FROM TOP THE LIGHT: The top photo is looking down from the lighthouse on what by 1870 was the town center, what we call today the Old Village. The ice cream sign on the roof of the building at far right marks the Atlantic Saloon, an ice cream store run by Alfred Harding. The building in the center is the Hammond House. Harding's ice cream store has been replaced by a residence and the Hammond House has been expanded over the years. Most recently, it was divided into condominiums with great views of Chatham harbor. While some houses have been added, most of the original 1870 houses remain. (Top photo: Chatham Historical Society)

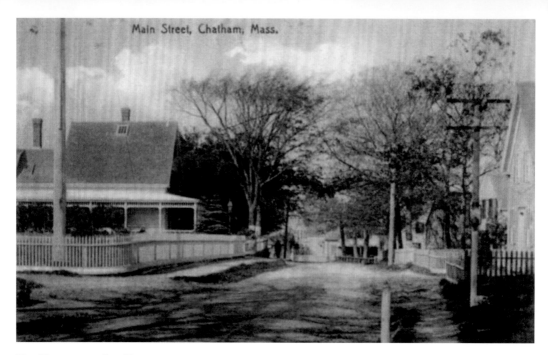

Main Street, Chatham, Mass.

THE HUB OF THE OLD VILLAGE: Andrew Harding's hardware store was located just north of Wilderwood Lane. Although Harding died in 1919, the store was kept open until World War II. The author Joseph C. Lincoln, a Boulevard neighbor who spun tales of old Cape Cod, was a frequent visitor. Some say Lincoln's inspiration came from the store's customers. Following the war, the building was sold and converted to a private home. The building was turned on the lot and it was photographed many times thanks to the American flag painted on the side of the front porch and the beautiful red beech tree in the yard. (Top photo: Chatham Historical Society)

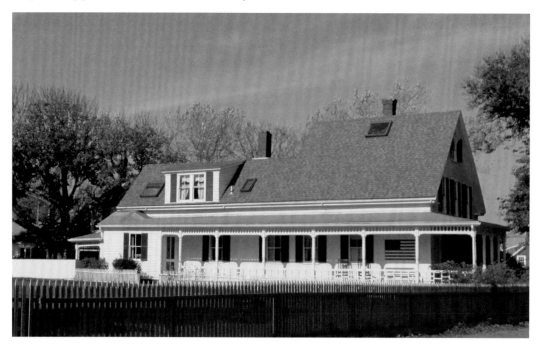

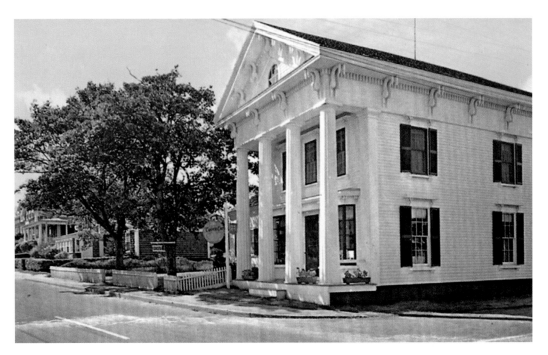

A Colorful Paint Job: The Greek Revival and attached half-Cape, some steps further on towards town, has given a certain panache to the formerly white Calico Cat Gift Shop. It was built in 1840 by John Hallett for his wife to run. When it was purchased in the early 2000s to be converted to a residence, the new owners requested to move the house back from Hallett Lane, among other changes that neighbors frowned on. The request was denied. Painters arrived one day and painted it several shades of green. No paint color regulations existed. It continues to be a shop run by Capabilities, a local nonprofit. (Top photo: Chatham Historical Society)

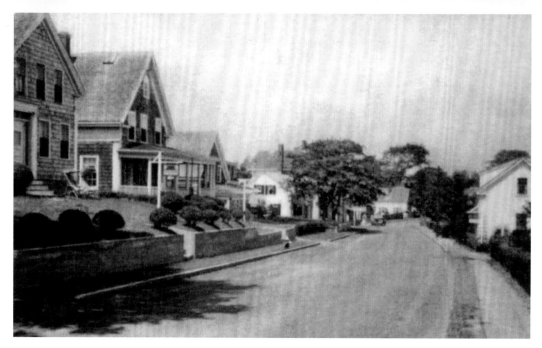

MARINERS ON MAIN STREET: A row of mariners' homes lined Main Street in this early 20th century postcard. It's interesting to note that no one who sailed the seas professionally chose to build their homes on the shoreline. At this point, Main Street is at least a block away from the coastline. Today, on the other side of the street is an antique home that retains much of its original simplicity. Chatham has tough regulations to try and preserve its historic buildings. The house above on the far left was the home of Captain Benjamin Kendrick Jr., now restored as you can see on the facing page. (Top photo: Chatham Historical Society)

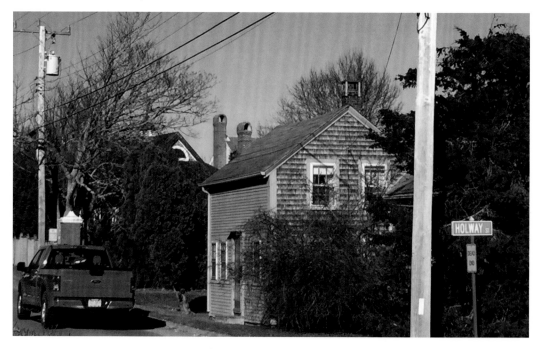

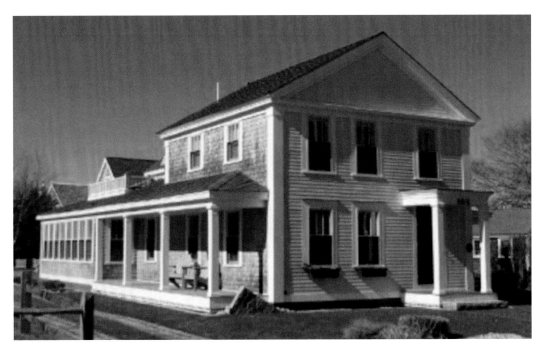

CAPTAIN HOUSE RESTORATIONS: The Old Village's place on the National Register of Historic Places reflects the value placed on preserving the architectural past. As we meander downtown, two homes are Chatham Preservation Award winners. Above is the home of mariner James Gould, a Greek Revival style that was built circa 1850 and restored to the design in an old photo. Below is the Captain Benjamin Kendrick Jr. house. He lived in the house until 1936. It was built prior to 1823, but the Captain's father purchased it around 1884. The home's façade was rebuilt to its original style, and a wing was added to the rear of the house, preserving the traditional lines of the historic home. (Photos: Chatham Historical Society)

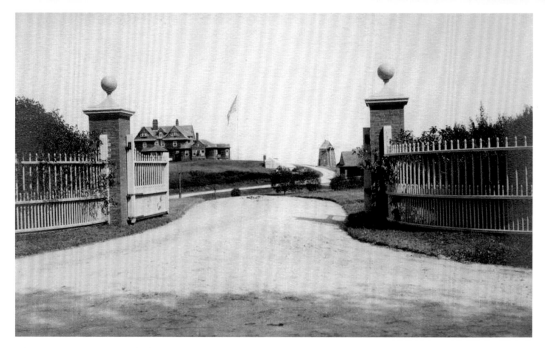

MARCELLUS ELDREDGE'S GATES: This imposing entrance to a prominent man's estate in Chatham's history, Marcellus Eldredge, is located just at the turning of Main Street towards downtown. When built in the late 1800s, Eldredge called it Watch Hill. He endowed both the library and the Methodist Church and those funds continue to support both organizations. Today, his mansion and fields have given way to a small neighborhood bordering on the water. The gates have been removed, but the entrance pillars and distinctive fence remains. Two of the outbuildings on the estate have been remodeled. (Top photo: Chatham Historical Society)

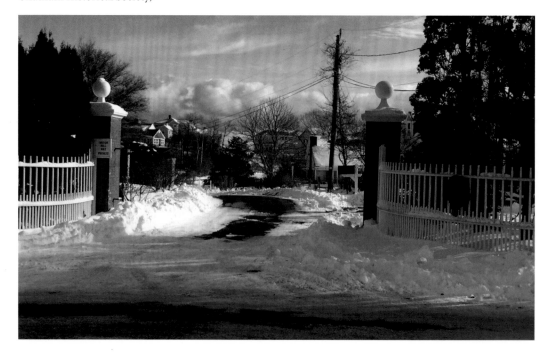

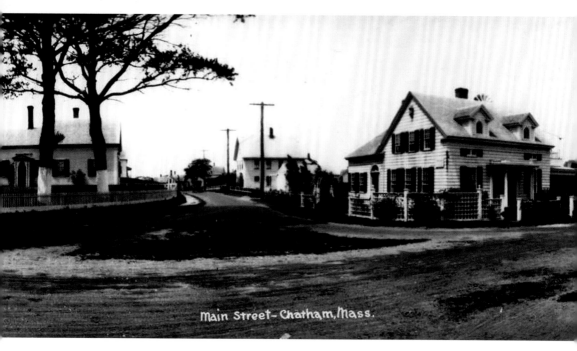

Main Street - Chatham, Mass.

A DESIGNATED SCENIC ROAD: Main Street from Bridge Street to Shore Road has been so designated because of Atlantic Ocean views and variety of architectural styles along the route. This early 20th century view of Shore Road and Main Street as it turns northwest towards downtown shows that sometimes things do remain the same—or close to it. The houses on the street are recognizable in the 21st century. The house at right was built circa 1830 for Silas Nickerson. In the 1950s, it was a tea room with cascading roses covering the arbor and fences. Today, it is a private residence. (Top photo: Chatham Historical Society)

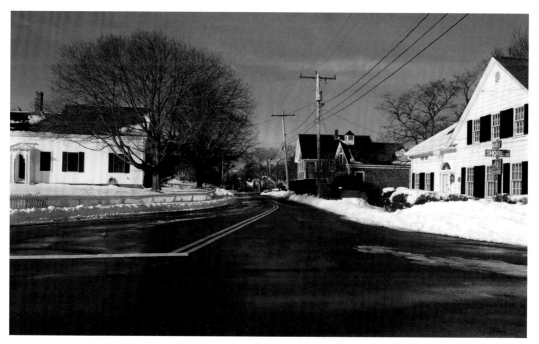

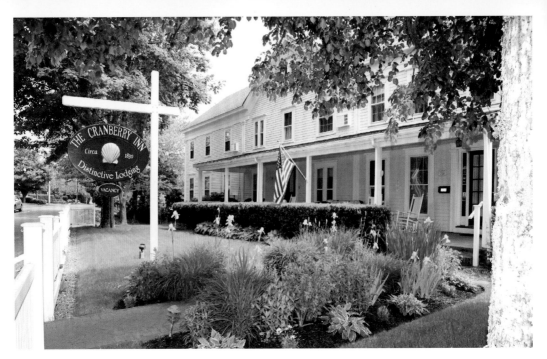

ONE OF THE OLDEST INNS IN CHATHAM: The Cranberry Inn during the 1990s was a destination for visitors who wanted to be close to the beach and near downtown. The Federal-style building dating from 1830 is one of the oldest ongoing inns operating in the village. Previously, it had been called The Travelers Home when it opened, and then the Monomoyick Inn. Completely remodeled in 2014, the building now houses the Chatham Inn at 259 Main, with a wine bar and tapas, providing a more cosmopolitan chic atmosphere than the Cape Cod Cranberry Inn. (Top photo: Chatham Historical Society)

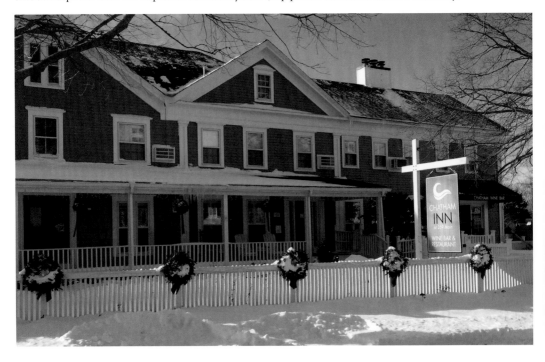

HEMAN HARDING'S HOUSE: A selectman and then state senator at the beginning of the 20th century, Heman Harding's house later became one of Chatham's celebrated restaurants, Christian's, during the end of the 20th century, shown above. The upstairs piano bar was a meeting place for Chathamites who liked to listen to Roy McArthur play and sing along with him. CDs were even made of some of their music. Today, the building has changed its tune and become a home decorating shop designed for both year-round and summer residents. (Top photo: Chatham Historical Society)

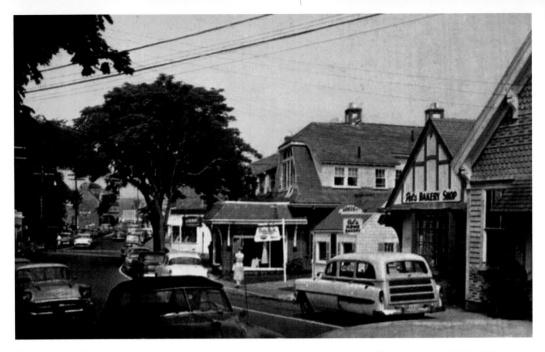

CHATHAM'S DOWNTOWN: In the 1960s, the commercial downtown formally began at the Tale of the Cod. A portion of the building is at the far right of the photo. A fixture in town since 1960, it was first a gift shop, but furniture was added in the mid-1980s. Pat's Bakery was next door. The side of the Brick Block is visible with a shop window featuring women's clothing. While the Tale of the Cod remains, art galleries, gift shops, and clothing boutiques have replaced more utilitarian sites. Chatham's downtown is a shopping mecca, not only for visitors but its residents, who find the historic storefronts and boutique atmosphere a welcome change from malls. (Top photo: Chatham Historical Society)

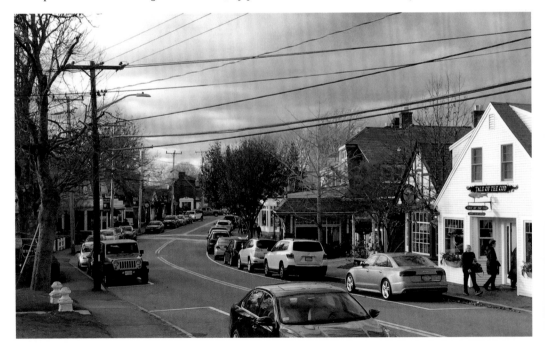

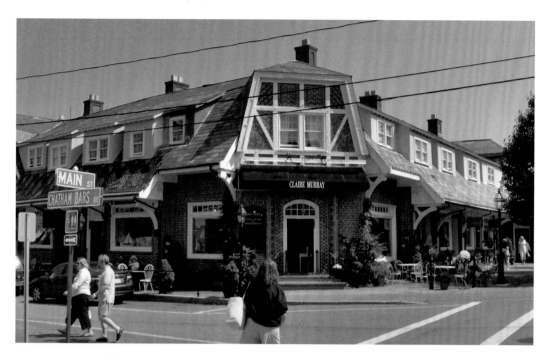

THE BRICK BLOCK: At the corner of Main and Chatham Bars Inn, the Brick Block was built in 1914 for Boston stockbroker Charles Hardy and associates. Listed on the National Register of Historic Places, the half-timber English Tudor style building was designed by Boston architect Harvey Bailey Alden. Joseph Nickerson, a local master mason, provided the intricate brick façade. Its two stories stood out when first built among the converted residential to commercial streetscape. It was designed with stores on the first floor and apartment residences above. Today, the anchor store on the corner is a clothing boutique with a variety of shops on either side.

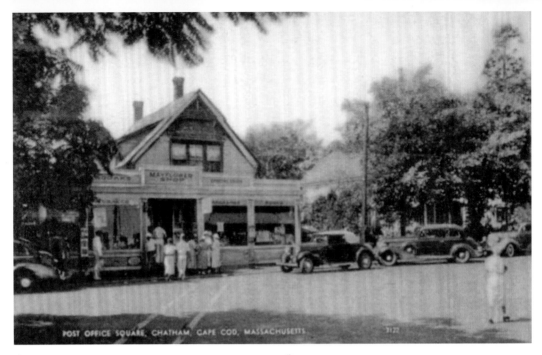

THE MAYFLOWER ON MAIN: Certain shops in a town have a universal appeal and for many years The Mayflower was *the* place to go for newspapers, magazines, greeting cards, stationery, and to find out what was really happening in town. In recent years, it has become more of a gift shop. The addition of a shopping annex replaces the photo studio of Kelsey-Kennard, famous for aerial photographs of Chatham. It was once the trend in most homes to have one of these, usually of local sandbars and shoals, which are nature's artwork. (Top photo: Chatham Historical Society)

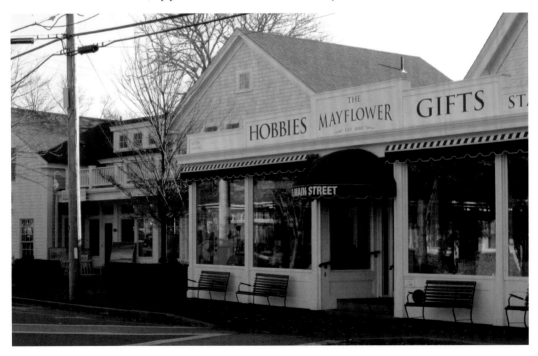

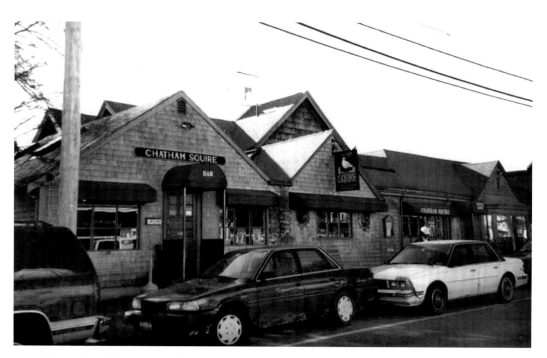

SQUIRE'S IN DOWNTOWN CHATHAM: A first stop for many summer residents and vacationers since 1968, the Chatham Squire has its regulars—business men and women, as well as retirees—for both lunch and dinner. The cozy bar and dining room in the restaurant serves a more traditional clientele, interested in good food and conversation. The rustic tavern next door caters to a younger crowd, including families. Evenings in the tavern bring out trivia fans and music lovers. Below, 46 years later, you see the people who made this destination eatery a main stay on Main Street. (Top photo: Chatham Historical Society; Bottom photo: The Chatham Squire)

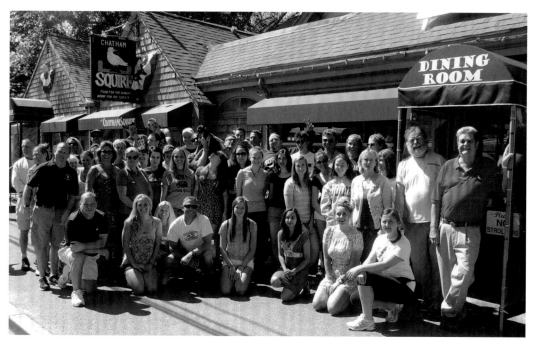

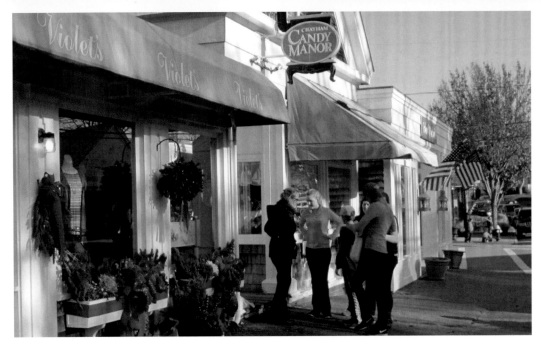

SHOPS THAT ARE SPECIAL: Across the street from Squire's is a row of stores that runs from the corner of Chatham Bars Avenue to Kate Gould Park. The stores are located in historic renovated homes that line the area. Shown above are two special shops. Violets entices women into its shop because of the jewelry and accessories in its windows. Next to it is the Candy Manor, from which aromas from its famous fudge draws candy lovers of all ages. Closer to the park are art galleries. Originally featuring the work of two local women artists, M. L. Falconer and Debbie Hearle, the galleries have expanded to include a variety of artists and their artwork.

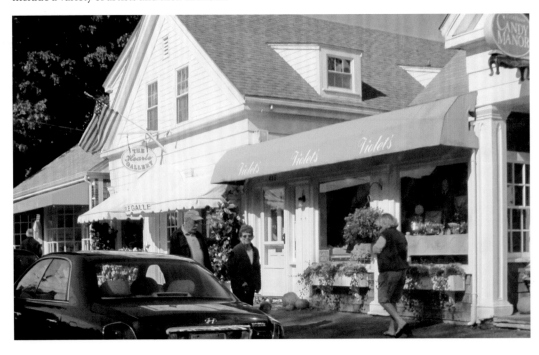

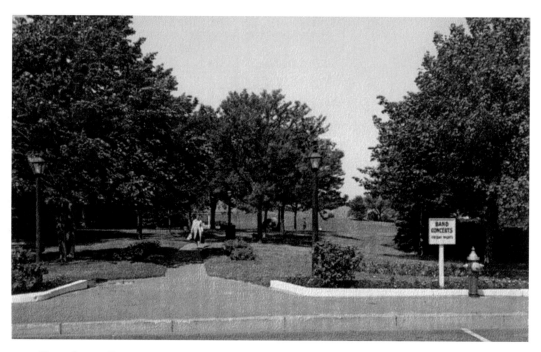

KATE GOULD PARK: This mid-20th century photo of the park, which bears the name of the woman who donated the property to the town, includes a "Band Concerts" sign, and through the trees it's possible to make out the bandstand. That bandstand, now named for Whit Tileston, a longtime conductor of the Chatham Band, along with the Chatham Lighthouse, are perhaps the most familiar Chatham landmarks. The bandstand was moved from its original location down the block next to the Town Hall, as shown in the photo below. The band concerts, which take place each Friday evening in July and August, draw about 6,000 people to the town. (Photos: Chatham Historical Society)

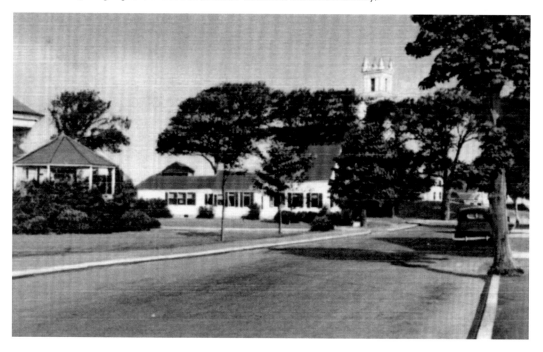

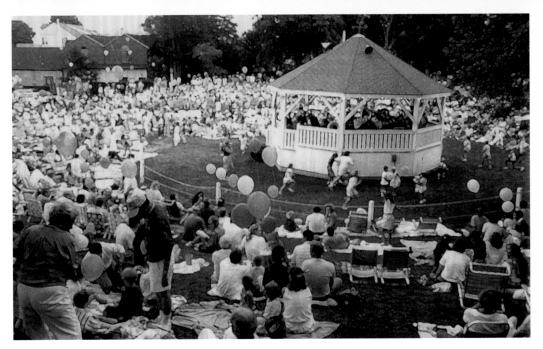

CHATHAM'S FRIDAY NIGHT CONCERT IN THE PARK: From the first Friday in July to Friday of Labor Day weekend, the Kate Gould Park on Main Street is where *everyone* gathers to attend free weekly concerts of the Chatham Band. The concert begins at 8 p.m., but people bring blankets and chairs earlier to ensure a great "seat." Debuting in 1932, the band was silent during World War II, but revitalized in 1945. Lively music, talented musicians, and time for dancing around the bandstand mark its concerts in the park then and now. Cape musicians vie to become members. The bandstand was named in 1986 for conductor Whit Tileston, who led the band for 48 years. (Photos: Chatham Historical Society)

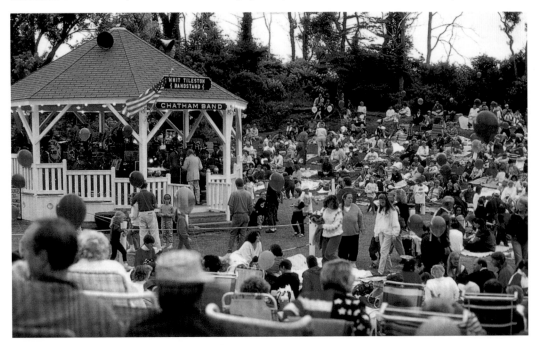

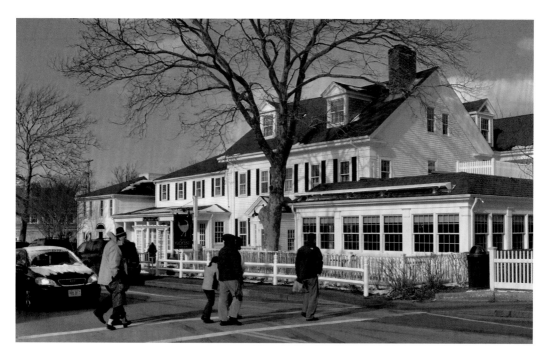

THE WAYSIDE INN: One of Chatham's oldest continually operating inns, the Wayside Inn began as a sea captain's house circa 1860. The Wayside Inn was originally called the Ocean Inn, when it was converted from a residence to house summer visitors. Over the years, it has been expanded and today offers rental cottages in addition to its 56 rooms. There is a swimming pool for guests and the inn's restaurant, The Wild Goose Tavern, is known for its food and atmosphere. One of the tavern's rooms features a mural of Chatham's landmarks. Most recently, an outdoor dining area was added so patrons can enjoy the weather, look out on Gould Park, and people watch.

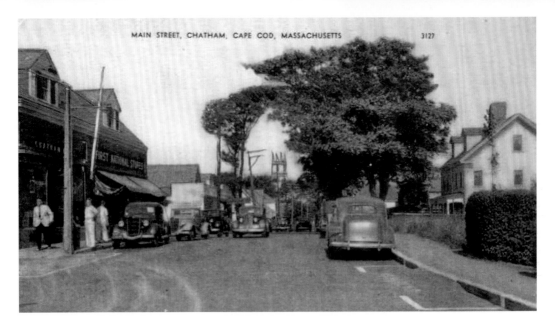

A FORMER GROCERY STORE: The Yellow Umbrella is one of three shops located where the First National market was located in the early 20th century. The grocery store made way for a clothing store, realtor, and Yellow Umbrella Books. Founded in 1980, Yellow Umbrella is the oldest book store in Chatham. Its trolley outside features used books and its window is replete with posters of the latest books on a wide variety of topics. Passersby can see themselves on the small TV screen in the window. Books by Chatham authors, as well as books about Chatham and the Cape, are featured along with bestsellers. (Top photo: Chatham Historical Society)

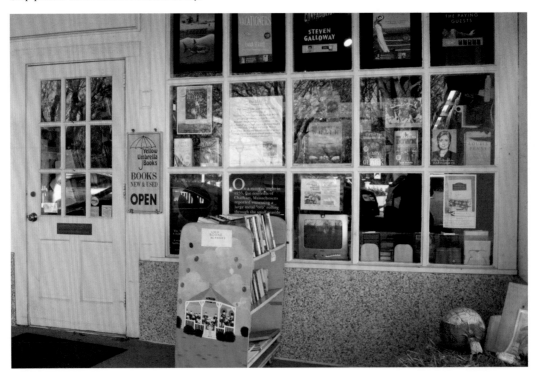

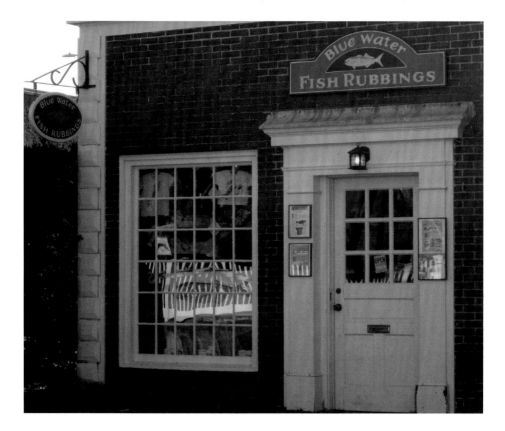

Two Local Specials: Continuing your stroll down Main Street, you will find two shops run by local merchants who really are special. Blue Water Fish Rubbings, *the* fish rubbing store, is run by artist Jenny Bovey. Fish rubbing is a Japanese art and Jenny produces textiles, clothing, and handcrafted papers decorated with the designs she creates. Yankee Ingenuity is the brainchild of Jon Vaughn, photographer and author, who has created a unique art gallery and gift shop featuring Cape Cod artists and crafts people, including his own photographs. These two artist/entrepreneurs illustrate the community of creative people who live and work on the Cape.

Sipping and Strolling: Chatham's downtown is ideal for strolling, filled with cafes and places to sit and enjoy life. Bikers pause on Main for refreshments and shopping. To many, sipping coffee or tea and chomping on some fresh scones or muffins is the ideal way to start a day—on vacation or not. That's why Chatham Cookware is one place to go. There's inside seating, but on good days there is nothing better than sitting on the chairs and benches on the porch and engaging neighbors as they pass by. A chairman of Selectmen used to take the pulse of the town with a cup of coffee in hand, sitting on a bench there.

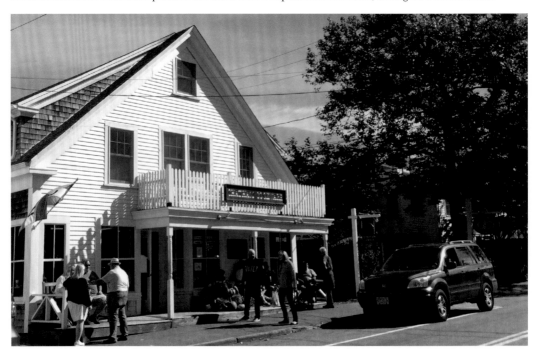

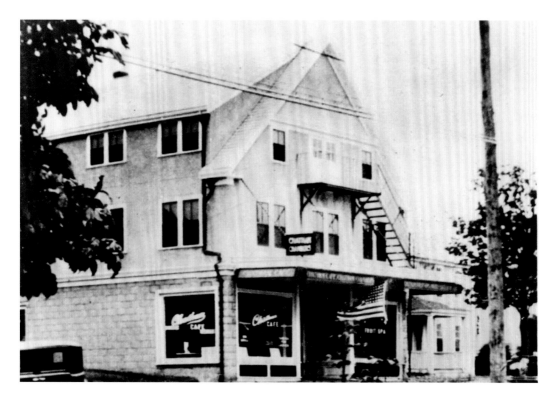

CHATHAM'S HIGH RISE:
Originally the home of tinsmith
Josiah Rogers Sr., the tallest
building in downtown Chatham
became a well-known local
eatery, the Chatham Café.
Apartments were upstairs. In
the 1990s, this was the home
of the Epicure, a cosmopolitan
liquor store. A remodeling
of the building to add luxury
condominiums upstairs took
place about this time. Today, the
Chatham Clothing Bar is located
on the ground floor shop and
those fire escapes have turned
into balconies. (Top photo:
Chatham Historical Society)

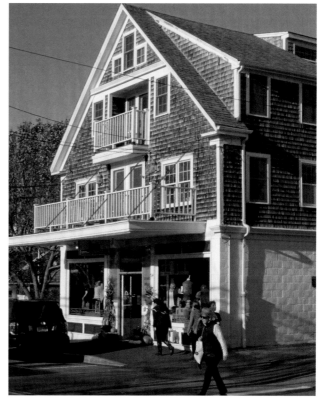

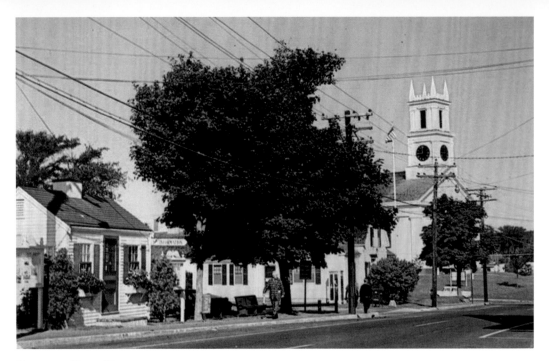

CHATHAM TOWN HALL: Chatham's Town Hall is nestled between the Visitor's Information cottage and the imposing Methodist Church. Formerly a private residence, it became the town hall in 1931. Over the years, it has been added to several times. However, in 2009, the town's business demanded more space and a Town Annex was built on George Ryder Road adjacent to the new Police Station. The idea was to provide some offices and services away from the hectic downtown location, especially during the summer season. (Top photo: Chatham Historical Society)

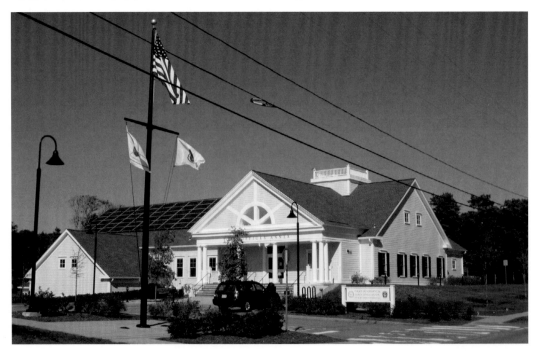

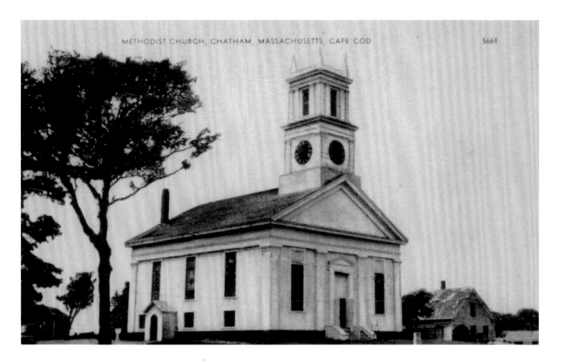

CHATHAM'S FIRST UNITED METHODIST
CHURCH: The church was built in
1849 at the corner of Cross Street and
Main Street. Endowed by Marcellus
Eldredge, the town clock is in its belfry
and remains a prominent and historic
landmark. Today, the church not only
conducts regular religious services, but
serves lobster rolls on Fridays during
the summer, keeping many band
concertgoers and townsfolk well fed. It
has been tradition for almost 30 years to
go to the Methodist Church for strawberry
shortcake after the Fourth of July Parade.
It is also the venue for chorales and
chamber ensembles on a regular basis
during the summer. (Top photo: Chatham
Historical Society)

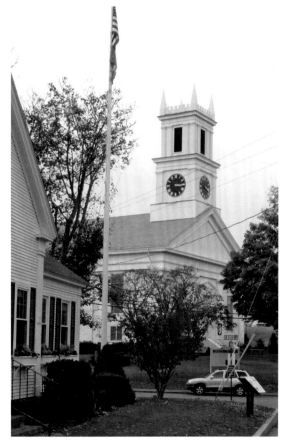

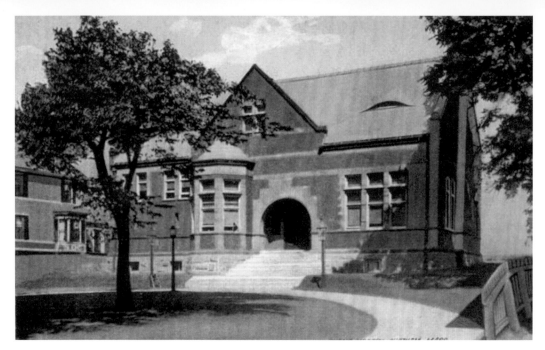

THE ELDREDGE PUBLIC LIBRARY: A gift of Marcellus Eldredge in 1896, the Romanesque Revival building is on the National Register. It was expanded in the late 20th century and despite the introduction of the digital age, it is still the center of learning and lifetime pursuits in Chatham. The circular driveway is no longer in place and there are fewer steps since a new landscape scheme was introduced. The main entrance was moved from Main Street to Library Lane at the time of the 1992 expansion. Aside from the latest bestsellers and a great children's section, there are poetry readings, seminars, classes, and a host of activities to engage all ages. (Top photo: Chatham Historical Society)

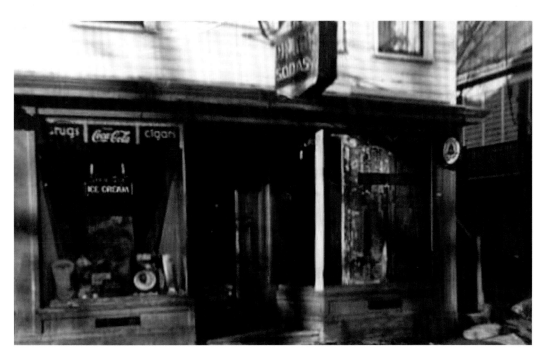

FROM PILLS TO PURITAN CLOTHING: Back in the day, Coffin's Drug Store (shown above following the 1944 hurricane) and Bearse's store were adjacent to the Methodist Church property. Puritan Clothing opened its first store on the Cape in Chatham in 1925. It serves both men and women with clothing and accessories. Uniforms were a big business for them and they wanted to be near the Coast Guard Station. Today the Puritan shop is a fixture on Chatham's quintessential Main Street with classic and designer clothing. Recently, the store offered Cape Cod apparel inspired by the Chatham Coast Guard. (Top photo: Chatham Historical Society)

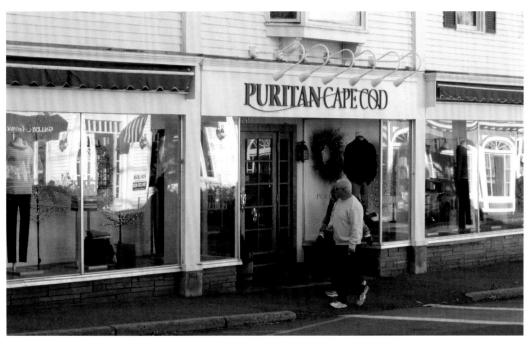

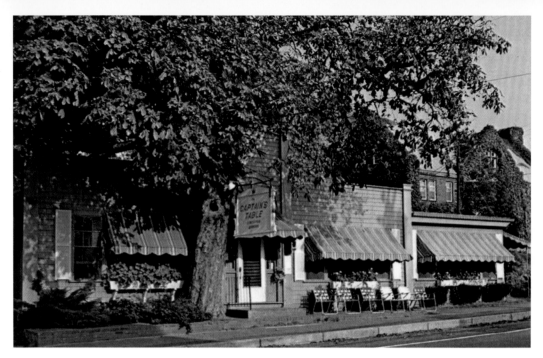

THE CAPTAIN'S TABLE: The Captain's Table has been in business over 50 years. Known for its chowder and lobster rolls, it is popular with residents and visitors. Today, it has downsized and added a catering arm. The popular eatery is located at the far right, where the flag is flying. Two other shops—a clothing shop and builder—occupy the now-white building. Gone are the awnings and the lovely old tree. One can still eat outside in an enclosed patio or indoors. It is open for breakfast, lunch, and dinner. (Top photo: Chatham Historical Society)

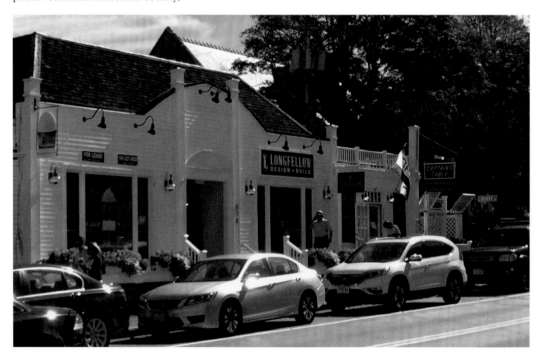

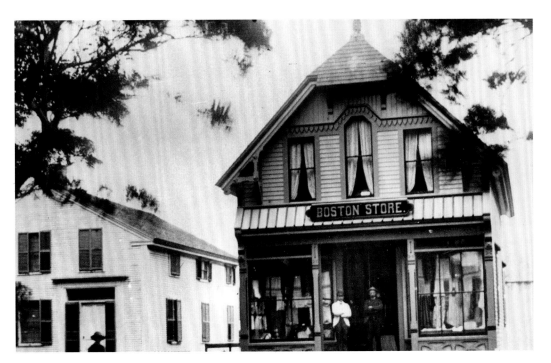

THE BUILDINGS RELOCATE: The Boston Store, a chain of clothing stores in the 1880s, had a shop in Chatham. The building was moved to its present location on Main Street, and an addition was built as well. Pentimento was established in 1978 and is housed in the expanded old Boston Store adjacent to the triangular park at Seaview and Main Street. If one looks closely, you can still see the original building's distinctive roofline and second story windows. The shop is filled with unique and singular fashions and has developed a bridal business as well. (Top photo: Chatham Historical Society)

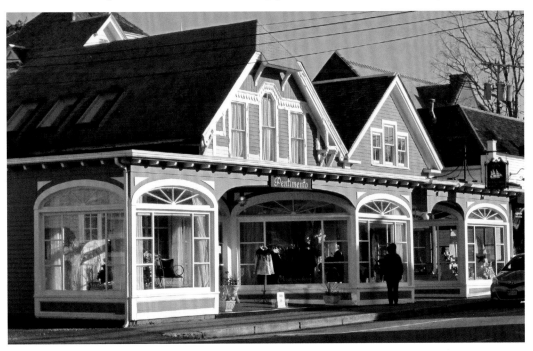

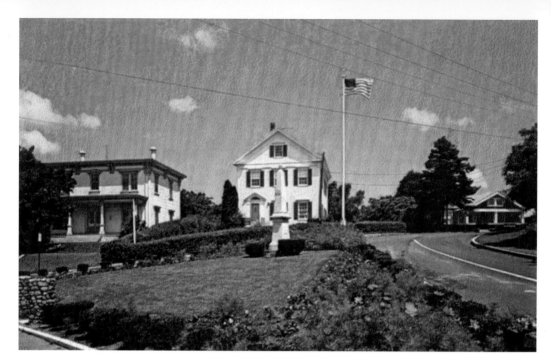

THE MEMORIAL OBELISK: Commemorating citizens who fought in the Civil War, the memorial is located in Sears Park, a tiny triangular space where Seaview Avenue meets Main Street. The house at far left on the hill is the Port Royal House, built in 1863 during the Civil War period and listed on the National Register of Historic Places, along with a host of other houses in town. The house in the middle of the photo above has been an antique shop for many years. The plantings in the park are much admired by visitors. (Top photo: Chatham Historical Society)

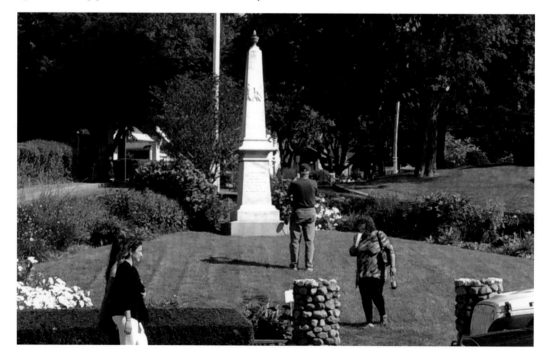

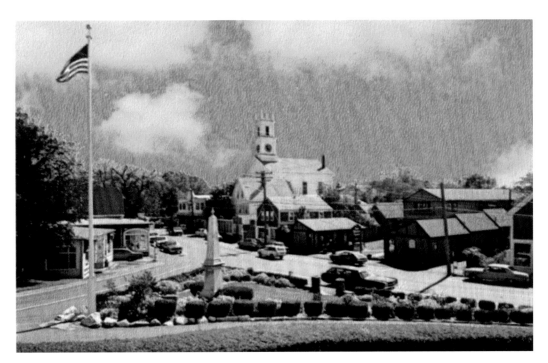

VIEW FROM PORT ROYAL HOUSE: This circa 1950 photo was taken from the porch of the Port Royal House and provides a good view of Main Street from town hall at far left, the Methodist Church, the Puritan Shop building, and other shops and stores, including a needlework shop and sporting goods store. The brown buildings were torn down and the Galleria was built in their place. It is Chatham's version of an indoor mall complete with restaurants and shops. Most recently, several other multipurpose buildings have been added, as has a vintage black pillar street clock. (Top photo: Chatham Historical Society)

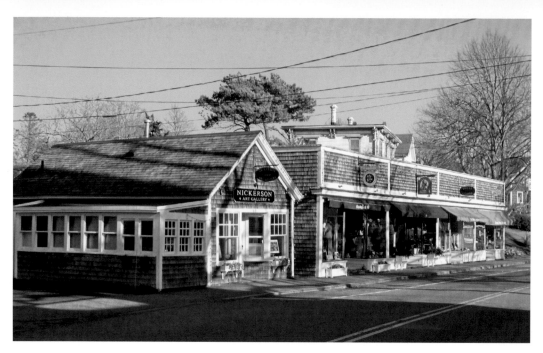

CHATHAM SHOPS: Just beyond Sears Park is a string of shops featuring women's designer clothing, jewelry, and home decorating accessories. Beyond that is where the marine antique shop, The Spyglass, used to be. Now it is the Nickerson Art Gallery. Beyond is The Chatham Hardware, a store with a long history. Today, it is best known for its pedal cars, metal cars for kids from the 1940s, a specialty aside from the expected hardware stock and gifts. Directly across from the shops is St. Christopher's Church. Originally the Universal Unitarian Church in 1870, it became an Episcopal church in 1960. The 21st century saw the church expanded to its present size. It has an active congregation interested in the arts.

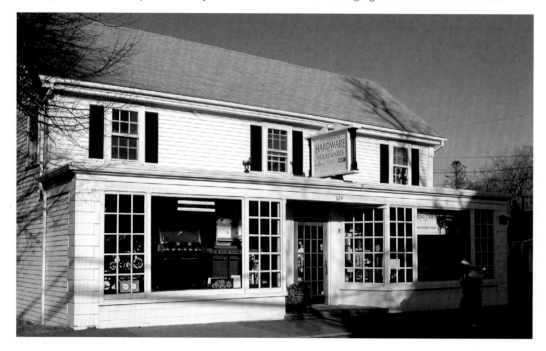

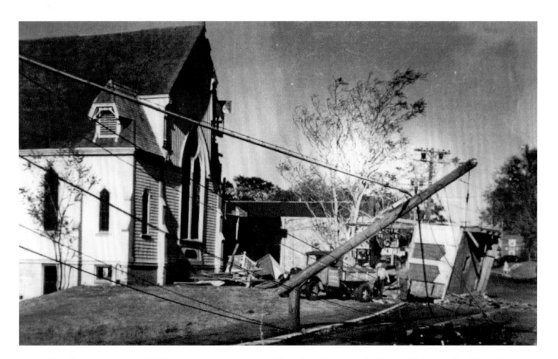

ST. CHRISTOPHER'S EPISCOPAL CHURCH: The church started off as a Universalist Church, dedicated in 1870. Above, the church's bell tower fell victim to a hurricane around 1944. The arch-shaped stained glass window and the façade became a landmark in town, with a new steeple built to replace the damaged one. During the 1960s, the church building was sold and St. Christopher's Episcopal Church became a Main Street feature. The building has been expanded at least twice since then, the most recent in the first decade of the 21st Century. It is now the site of seminars and concerts, as well as Evensong and other services in the Anglican tradition. (Top photo: Chatham Historical Society)

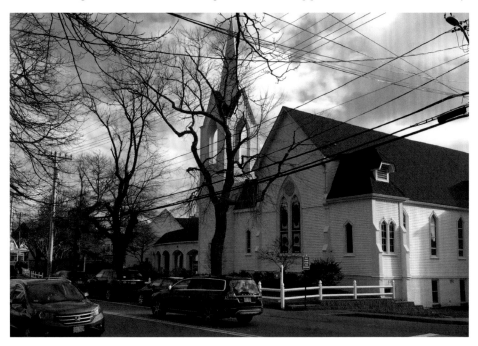

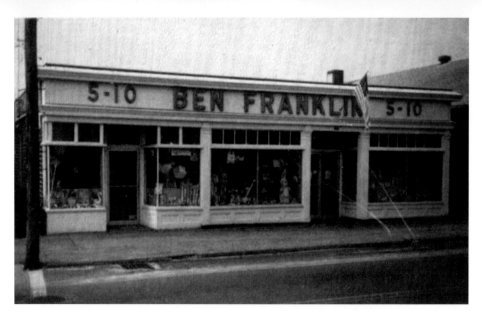

AN OLD-FASHIONED VARIETY STORE: Ben Franklin 5-10 has been a fixture in town for as long as most people can remember. It started out as a classic five-and-dime store but has morphed into a unique, old-fashioned variety store. (They claim there are only 194 in the whole country.) The Ben Franklin motto is "If we don't have it, you don't need it." Adults and children find it a trip back in time, and are able to find everything from fabrics and needlework supplies to toys and kites, with hats and tee shirts as well. Plus, it's open seven days a week, year-round. (Top photo: Chatham Historical Society)

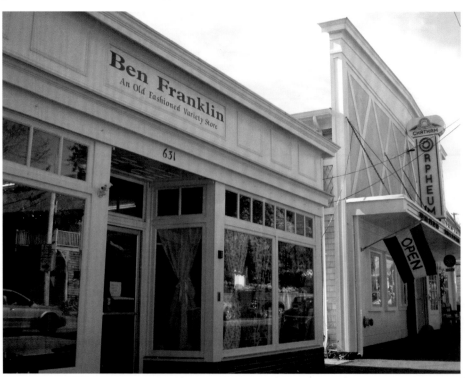

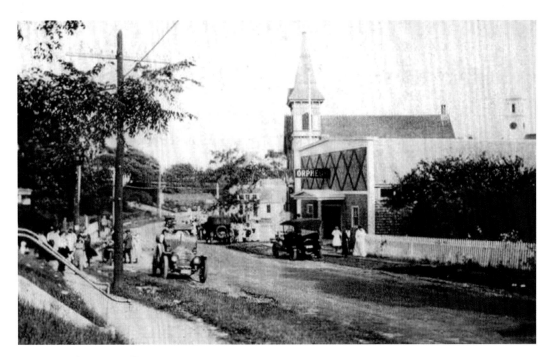

THE ORPHEUM THEATER: When the Orpheum opened as a movie theater in 1916, the films were silent. During its first run of 72 years, it saw the demise of silent movies and the introduction of the "talkies." Residents and summer visitors made it part of their lives—slapstick comedies, mysteries, war dramas—all bringing the world to Chatham. In 1938, it became the Chatham Theater until it closed its doors in 1987. A CVS drugstore replaced the movie house, which had also been the venue for high school graduations, town meetings, and other community events. The town lost more than just a movie theater; it lost some of its cohesiveness. (Photos: Chatham Historical Society)

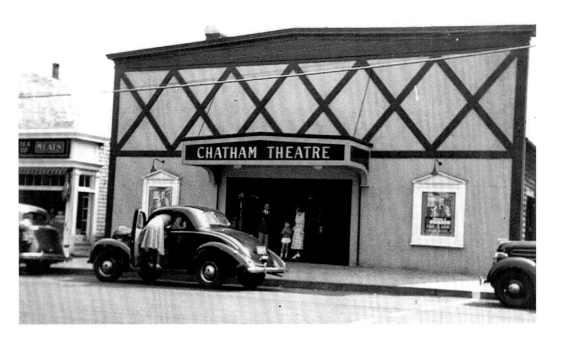

ORPHEUM THEATER'S REVIVAL IN 2013: When CVS decided to move down the street, a grassroots movement to buy the building and return it to its former use as a movie theater—but as a state-of-the-art two-screen theater with its own café—was undertaken by local volunteers led by Naomi Turner. They raised $3.6 million in donations and some major grants. Today the nonprofit theater features Hollywood blockbusters as well as independently and locally produced documentaries and films. It also showcases local artists including Hans de Castellane's mural, *The After Party*, in the foyer. It revived its cachet as a venue for community events including informational presentations and fundraisers for other local nonprofits. (Bottom photo: Orpheum Theater/Geoff Bassett)

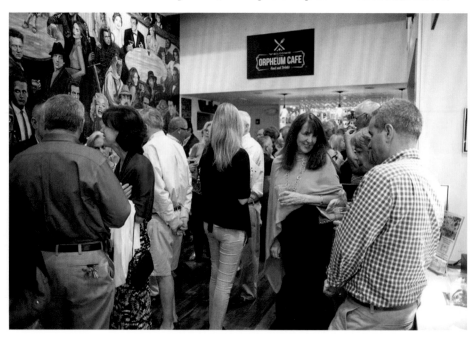

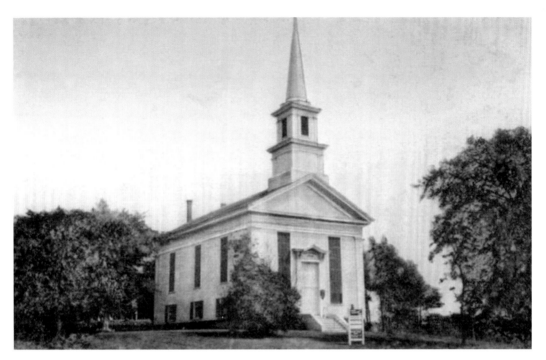

CHATHAM'S CONGREGATIONAL CHURCH: The church's current building was constructed on the rotary using the framing from the original meetinghouse dismantled in 1866. The building has been updated over the years including the electrification and preservation of its 1848 chandelier. Its steeple was struck by lightning in 1887 and was repaired using part of the mast of an old ship, the R. A. Allen. In 2015, the steeple again needed refurbishing. In the fall, the front lawn becomes a Pumpkin Patch and this is the best place to buy your Halloween jack-o-lanterns or your Thanksgiving decorations. The church has been a community hub since Chatham was founded and continues to be a focus for the community today. (Top photo: Chatham Historical Society)

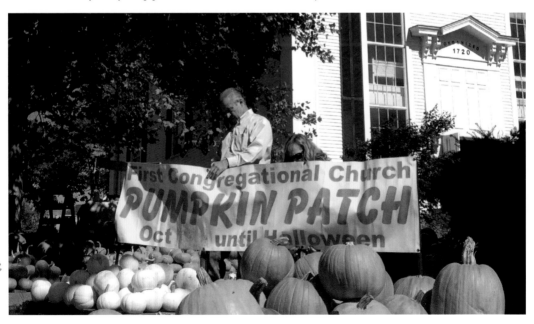

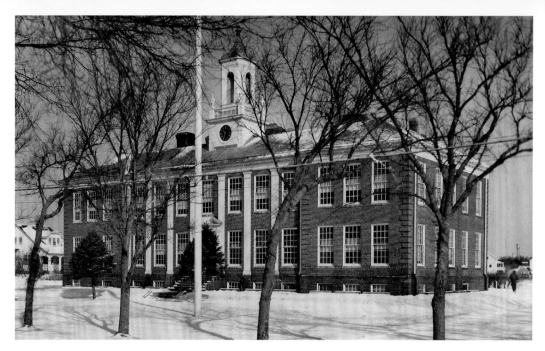

CHATHAM'S COMMUNITY CENTER: The building began life as the town's high school back in 1924 for grades 1 through 12. In June 1998, the school officially closed with a reunion of former students. After being closed for several years, the townspeople decided to convert the old building into a much-needed recreation and community center. In 2007, it was officially opened as a place for young and old to gather for recreational purposes as well as meetings. The rear of the old building was torn down to make way for this imposing entrance. It's location adjacent to the baseball field, Veterans Parks, and the town's playground makes it a draw in winter and summer. (Top photo: Chatham Historical Society)

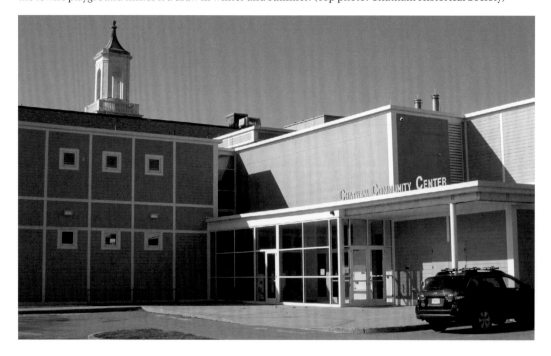

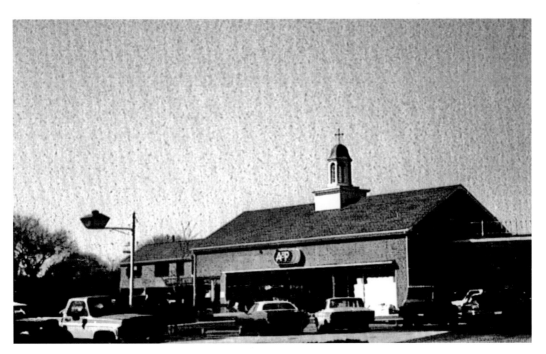

EVERY TOWN NEEDS A GROCERY: In the 20th century, Chatham had a grocery store—first the Atwood Store, then the First National, and finally two A & P stores. When the last A & P location on Main Street at Queen Anne Road was closed in 2003, former employees bought it and reopened as the Chatham Market. Eight years later, with CVS moving to the location, the site was completely cleared and new buildings constructed to house both a drug store with a pharmacy and the Chatham Village Market. The strong support of residents, who wanted a grocery store in their town, made it happen. (Top photo: Chatham Historical Society)

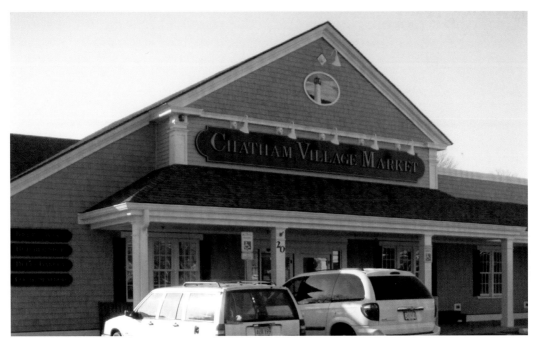

WEST MAIN STREET: While the street was residential when this photo was taken, today the scene is quite different. The house partially hidden by the telephone pole became the Sou'wester, a restaurant and nightspot for many years. Today it is probably one of the most unique Dunkin Donuts shops in the country, being housed in a renovated historic home. The house across the Main Street is the current headquarters of the Cape Cod Commercial Fishermen's Alliance. (Top photo: Chatham Historical Society)

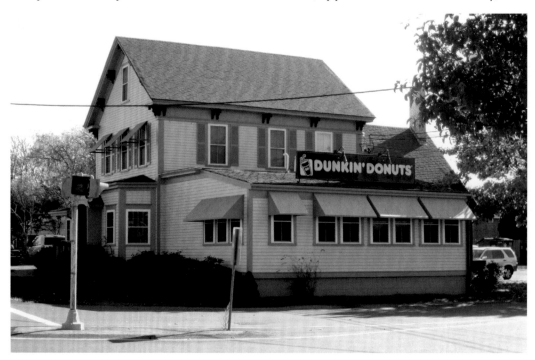

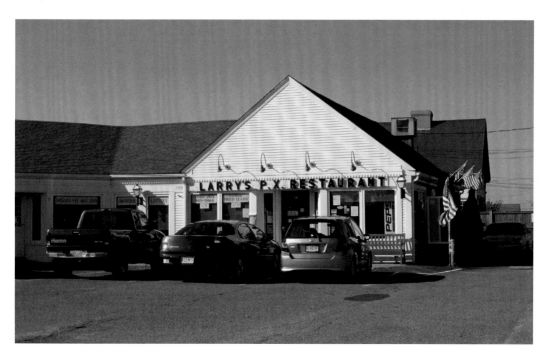

SOMETHING OLD AND SOMETHING NEW: In this same West Chatham area stands an eatery where fishermen, old timers in the town, and wash-a-shores have gathered for decades. It is Larry's PX, the hangout for all of the above, and a landmark for many. Across the street and behind the Fishermen's Alliance building, something new is happening. Habitat for Humanity is building four homes that are slated for completion in mid-2017. Habitat builds homes for people in need using volunteer workers. Affordable mortgages are offered to working families so they can stay on the Cape. This development is possible through residents' support and through the Community Preservation Fund supplied from real estate taxes.

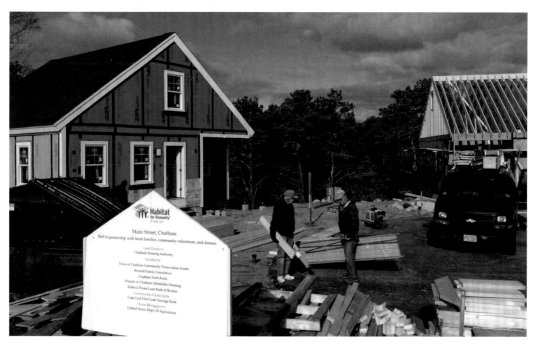

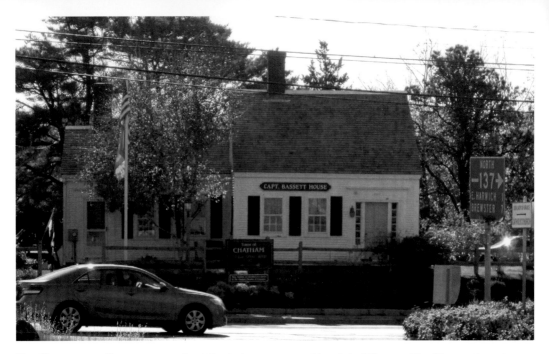

THE COMMUNITY PRESERVATION ACT: The desire to conserve historic buildings and land is a sentiment that runs through Chatham residents. It is part of the town's DNA and that's why the townsfolk passed the Community Preservation Act, which helps communities preserve open space and historic sites, create affordable housing, and develop outdoor recreational facilities. Conservation efforts took place even before the passing of the act. For example, the Captain David T. Bassett home in South Chatham was restored to house the Chatham Chamber of Commerce. The most recent restoration of the Godfrey Grist Mill is another example.

3

REMEMBERING OUR HISTORY

THE MAYO HOUSE: Across Main Street from Town Hall, the Mayo House is a restored Cape Cod style house —what is called a three-quarter Cape—built in 1820. This antique home is the headquarters of the Chatham Conservation Foundation, and is used for its regular meetings. When the Cape Cod Five Cents Savings Bank built their present branch building next door, the house was moved and donated to the foundation. Furnished with period furniture, it is open to the public from mid-June through September three days of the week. (Photo: Chatham Historical Society)

THE ATWOOD HOUSE MUSEUM: Built around 1752, the museum is the home of the Chatham Historical Society. It was the brainchild of the Chatham Ladies' Reading Club, whose members wanted to preserve the records and objects related to the town's history. It was 1923. Antique dealers were buying up such items and the seafaring way of life was disappearing. The culture of the town was slowly vanishing. They bought Captain Joseph Atwood's full Cape in 1926 as a museum. Later, the society outgrew the house and added several rooms, including the Mural Barn to house Alice Stalknecht's paintings of townspeople. A major expansion was completed in 2005, providing offices, and costume and archival areas on the lower level. (Top photo: Chatham Historical Society)

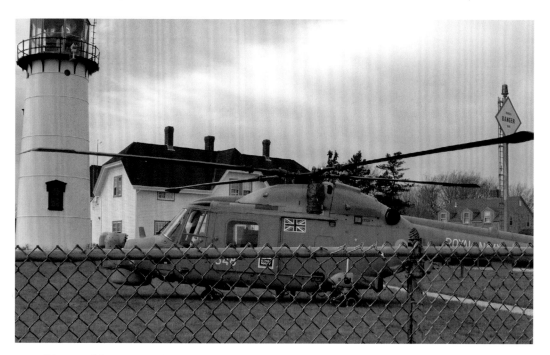

HISTORY MADE AT THE MUSEUM: For the first time since the War of 1812, a British naval ship arrived in Chatham waters. HMS *Chatham* was commanded by Captain James Morse, who had requested to visit the town that bears the ship's name on his last voyage to Boston and home. The *Chatham's* crew arrived by small boats. Chatham's harbor wasn't deep enough for the frigate. Captain Morse's arrival was via the ship's helicopter, which landed at the Coast Guard station. After town officials welcomed him and his crew, they were taken to the museum. Spencer Grey, then Chairman of the historical society, is shown below pointing out a painting of a British ship captured by the Americans in 1813.

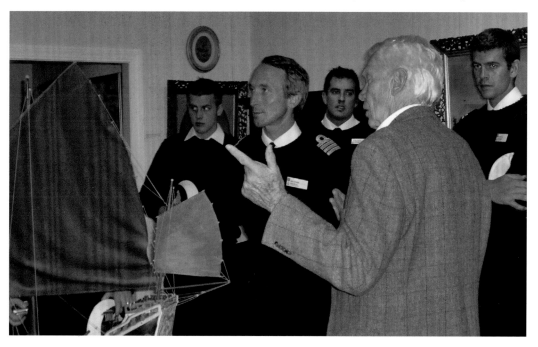

CHATHAM'S FOUNDING FATHER: William Nickerson built his homestead near Pleasant Bay, and today the Nickerson Family Association has its headquarters there as well. On the front of the property is the home of Caleb Nickerson, the great great grandson of William, built in 1772 on a bluff overlooking the Oyster River. In 2003, the house was moved by both land and sea to its present location. The building at the rear of the property houses the association's headquarters, with extensive genealogy records of the Nickerson family and related clans. The Revolutionary-period house is open to the public. The interior and grounds mirror life during Caleb's time and costumed docents are there to inform visitors. (Bottom photo: Robert C. Webber)

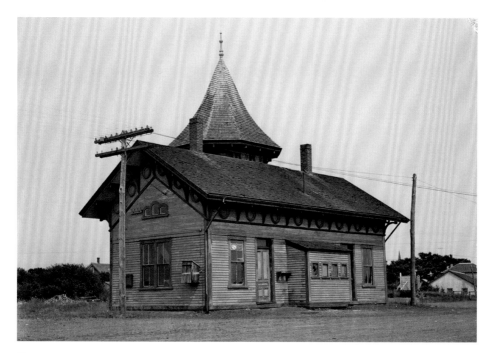

THE RAILROAD MUSEUM: Located on Depot Road, the museum is housed in the old Chatham Railroad Company station, a spur of first the Old Colony Railroad and then the New York, New Haven and Hartford Railroad. The ornate Railroad Gothic building is over 100 years old and on its original site. The railroad arrived in 1887 and served the town until 1937. Mr. and Mrs. Jacob Cox of Cleveland and Chatham purchased the rundown structure and land surrounding it in 1951 and gifted the town with it. It was completely restored as a country railroad depot and museum in 1960. A caboose is stationed in the rear of the building for visitors. (Top photo: Chatham Historical Society)

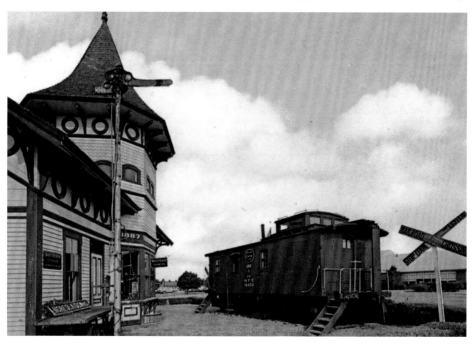

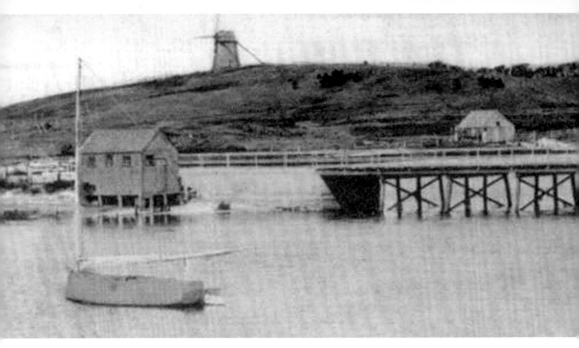

THE COLONEL BENJAMIN GODFREY GRIST MILL: The mill stood on Mill Hill overlooking Mill Pond from 1797 until 1956. Vintage postcards of the Mitchell River Bridge show its outline in the background. It was moved from its original location, off Stage Harbor Road, in 1956 moving in two major parts up along the streets of the town to its present location atop a hill in Chase Park. The move was a major one; telephone and electrical wires had to be moved for the main part of the structure to pass through and the efforts drew townspeople to watch the delicate maneuvering of the mill's pieces to its present site. (Photos: Chatham Historical Society)

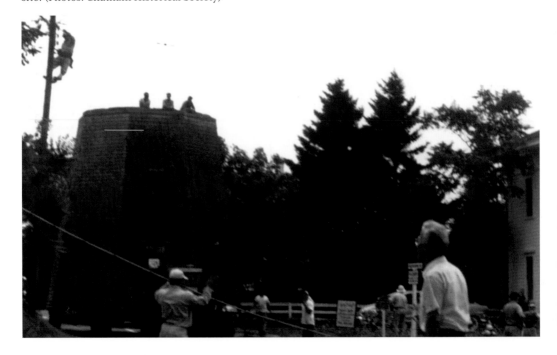

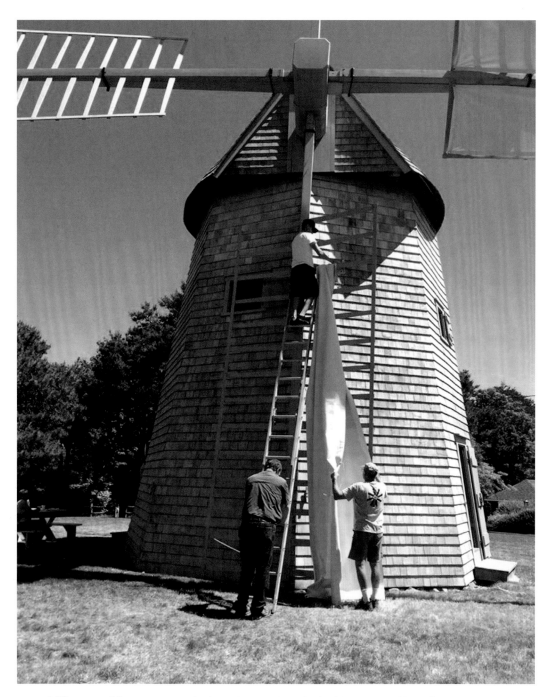

A HISTORIC MILL: Historic Chatham Grist Mill, as the Godfrey Grist Mill is called on signs directing visitors along Shattuck Place, is commonly known as the Chatham Windmill. Over the years, this landmark has been restored several times. From 2009 to 20012, extensive restoration made it fully functional so it could grind grain into flour, just as it did in the 18th and 19th centuries. This photo was taken in June 2016 as part of the preparation of the mill for grinding. Millwright/mill restoration specialist Andy Shrake, assisted by Chatham Windmill Group volunteers, attaches cloth to the sails or vanes of the windmill. (Photo: Chatham Windmill Group)

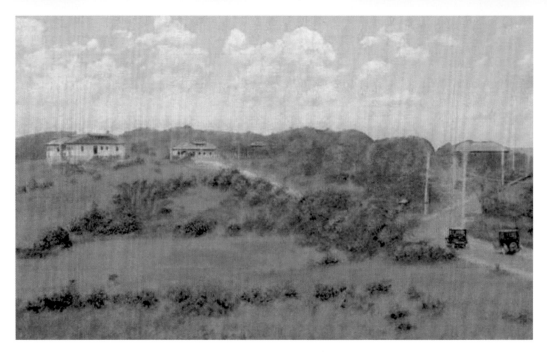

A NEW MUSEUM: The Chatham Marconi Maritime Center is the town's newest museum, opened in 2013. Located on the site of the short-wave radio station built by communications pioneer Guglielmo Marconi in 1914, it includes a museum in the historic Operations Building and an Education Center in what was known at the time as the hotel, or residence for single men at the station. The station was part of Marconi's visionary wireless network that was planned to link America with Europe and Japan. Under RCA it was known by the call letters WCC and was the busiest ship-to-shore stations on the East Coast during most of the 20th century. (Top photo: Chatham Historical Society)

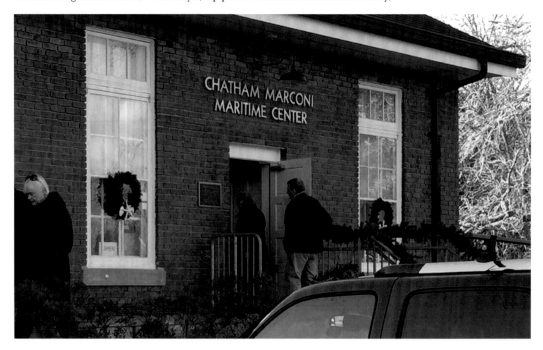

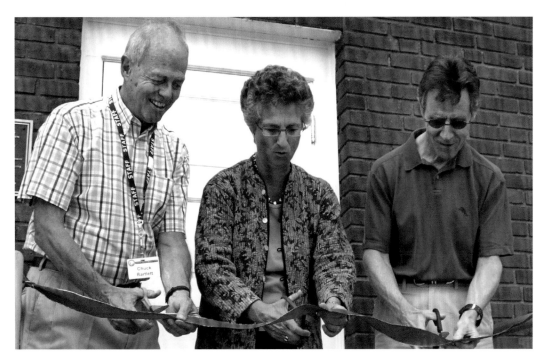

RIBBON CUTTING: The Marconi Museum's opening featured local officials. Marconi's daughter Princess Maria Electra Giovannelli was present as well. The museum tells the story of Marconi, how the station's Morse code operators communicated with ships across the world even 100 years ago, and a recently discovered World War II mission kept secret for many years, that allowed the Chatham station to monitor German U-boats in the Atlantic. You also have the chance to practice Morse code. Several videos describe Marconi's invention and the Atlantic sea battles. There is a diorama of the original Marconi wireless station including all the buildings and the antenna field seen below center. (Top photo: *The Cape Cod Chronicle*/Alan Pollock)

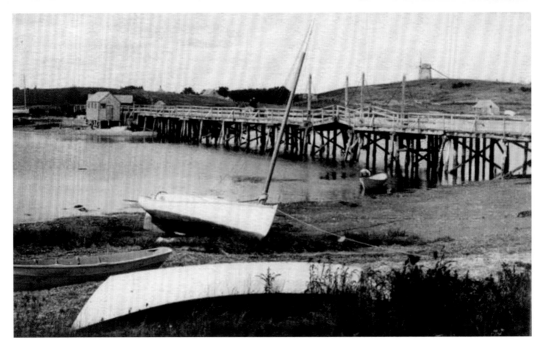

THE MITCHELL RIVER BRIDGE: An important link between Toms Neck and Stage Neck for at least a century, the bridge shortens a long trip around the shores of Mill Pond and Oyster Pond to Stage Harbor, and being a drawbridge still permits passage of boats with masts from Stage Harbor to enter Mill Pond and beyond. Above is one of the early photos of bridge with its bascule-type drawbridge. Below is a more contemporary version of the bridge from which townspeople have fished for years. This wintry scene shows just one lone fisherman, but warmer climes brings many more and you can note the broadened pedestrian walk from which one can throw a line. (Photos: Chatham Historical Society)

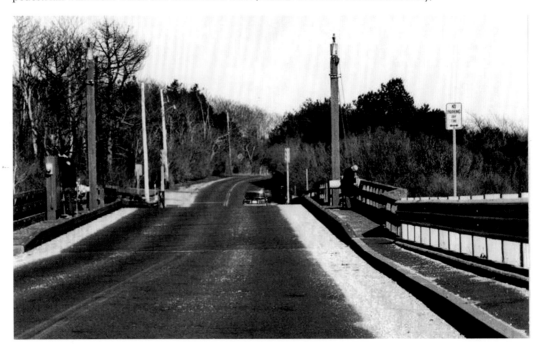

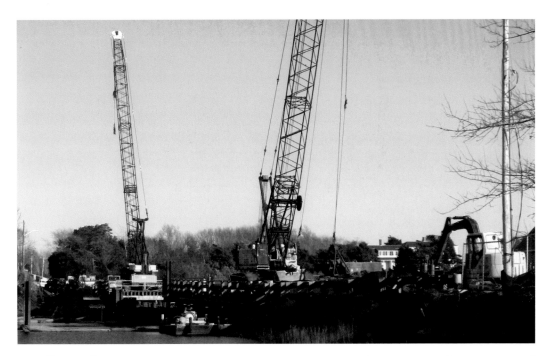

BRIDGE RECONSTRUCTION: The bridge needed work early in this century, so the state proposed replacing the bridge with a type they have used on many roadways. Concerned citizens, and Chatham has an abundance of them, felt the state ignored the history and importance of the bridge and fought for a customized design that considered this. Work took almost two full years, during which the importance of this shortcut from one side of town to the other was evident. Below you see the final version of the bridge, taken from a new deck structure that allows both fishing and viewing. Standing on this new deck, watching a large sailboat use the drawbridge to access Pease Brothers boatyard, is a view to behold.

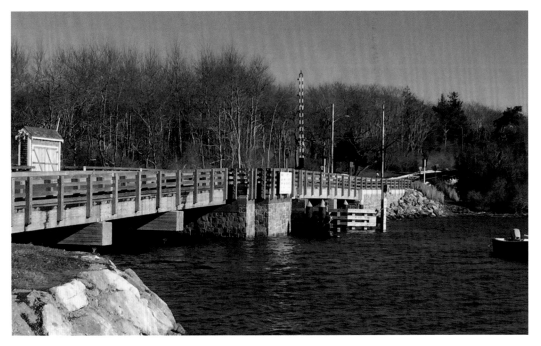

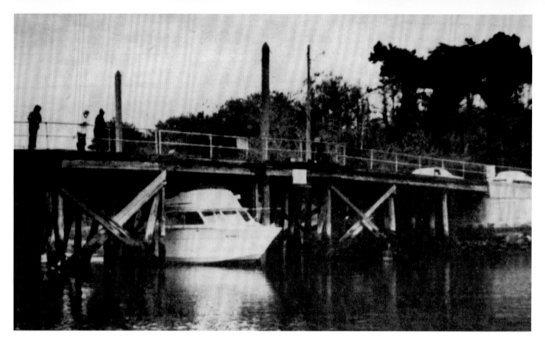

THE MUDDY CREEK BRIDGE: The bridge's construction had obstructed the free flow of water from Pleasant Bay to the tributary. In Chatham, it is called the Muddy Creek, while in Harwich it is called the Monomoy River. It is actually a town border. Back in the 1930s it really was a bridge boats could go under, but it was rebuilt with an opening reduced to a large oversize conduit. Construction of the new bridge allowing small boats to enter the river began, and was completed just over a year. Today, water flows unimpeded. Birdwatchers, kayakers, and canoeists can move from Pleasant Bay under the bridge to paddle up a river bordered by conservation lands. (Top photo: Chatham Historical Society; Bottom photo: © Christopher Seufert Photography)

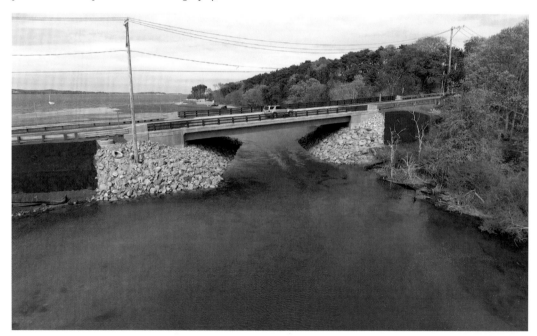

4

THE GOOD LIFE

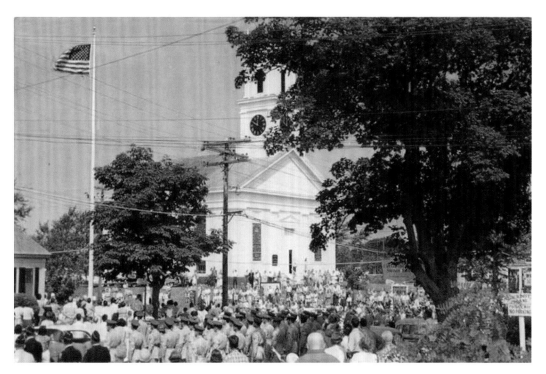

AN AMERICAN SMALL TOWN: Crowds gather to salute the flag in front of Town Hall in this mid-20th century photograph. The scene could be of any small town in America at the time. Citizens surround veterans, serviceman and the Chatham Band in front of the Methodist Church, probably for a Memorial Day tribute. God, mom, the flag, and apple pie all represent America and Chatham through time! (Photo: Chatham Historical Society)

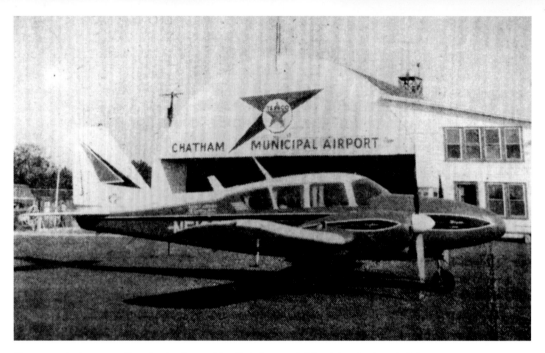

CHATHAM'S AIRPORT: Shortly after he got his pilot's license, Wilfred Berube founded the airport in 1928. He purchased 72 acres off George Ryder Road and started the Chatham Flying Services, moving mail and using his mechanic's expertise as well. Residents with small planes, as well as flying enthusiasts, found the airport convenient. Those private planes also bring summer residents and visitors to the elbow of the Cape. There are still mechanic repair and maintenance services at the airport, and airplane rides are also available. A restaurant on the second floor of the hangar is a favorite eatery for those who enjoy watching small planes taking off and landing. (Top photo: Chatham Historical Society)

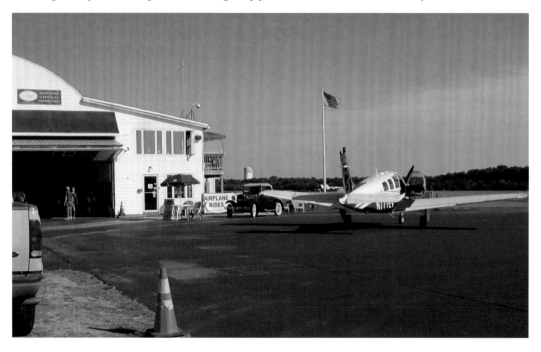

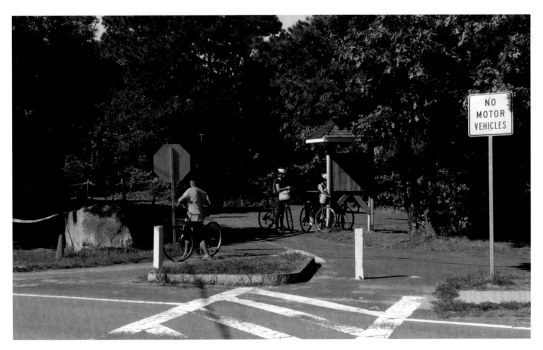

THE CHATHAM BIKE TRAIL: The trail swings by the airport along George Ryder Road, and usually follows the Old Colony roadbed. Visitors to Chatham have discovered that exploring the town by bike can be more relaxing than driving in the summer traffic. The photo above shows the bike trail where it crosses George Ryder Road and moves onto the old roadbed. Below is another view of the bike trail, next to the parking lot on Meetinghouse Road, where bikers can begin their excursion into town. Just across Route 28 is the Chatham Chamber of Commerce Information Center, where bikers can obtain maps of the trail and highlights they might wish to enjoy.

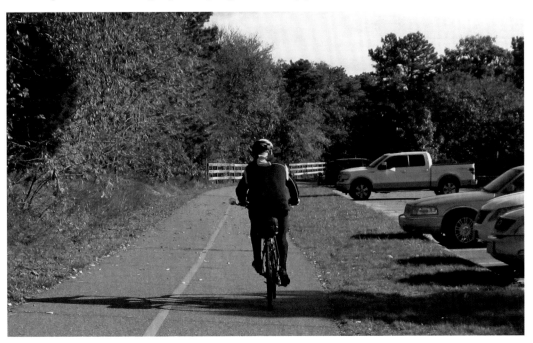

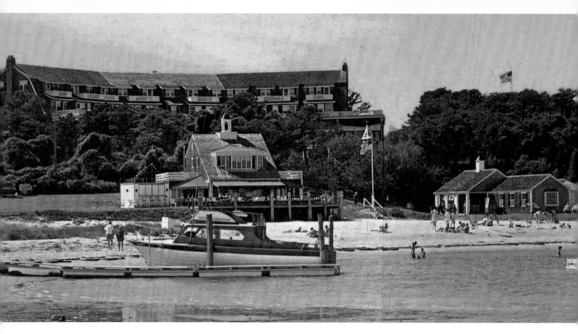

A WORLD-CLASS HOTEL: The Chatham Bars Inn was built by Charles Ashley Hardy and opened in 1914. The photo above shows the hotel overlooking the seaside restaurant, beach, and dock in the 1960s. Today, the historic inn, surrounded on both sides of Shore Road and along Seaview Street by 30 outlying cottages, has over 200 rooms. Some cottages are shown below. In 1944, two future queens spent the summer there. Princess Juliana, who was crowned Netherlands' Queen in 1948, spent several weeks at the resort with her three daughters, the eldest of which—Beatrix—reigned as the Dutch queen from 1980 to 2013. (Top photo: Chatham Historical Society)

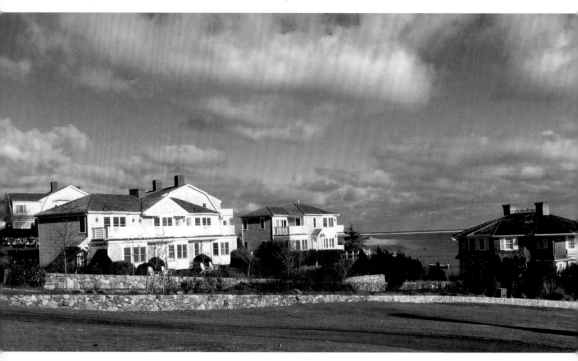

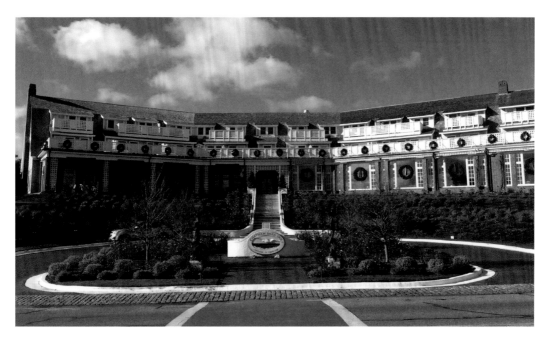

THE MAIN INN: There are 40 rooms in the inn, which provides beautiful water views, as well as the Stars restaurant for formal dining and the Sacred Cod for more casual dining. The veranda is a favored spot for coffee or drinks throughout the day. The lobby and first floor rooms of the main inn provide a wonderful place to play games or just read. The Beach House is located just steps from the sand and is a favorite spot during warm weather for the younger clientele. The lawns on the 25 acres of the inn are frequent sites for weddings. Some returning guests were first brought to the inn as children, and it remains a special place for them.

SUMMER THEATER: Monomoy Theater raised the curtain on its first play, a comedy, on July 2, 1938. That marked Chatham's first professional summer theater, run by Mary Winslow. Following her death in 1957, the theater closed and was up for sale. Fortunately, Elizabeth Baker, wife of the president of Ohio University, loved theater and saw an opportunity to have the university's drama department have its own summer theater. By 1958, the theater was back in business. Most recently, the University of Hartford and its Hartt School in association with the Friends of Monomoy Theater keep the theater up and running as one of Cape Cod's premier summer theaters. (Top photo: Chatham Historical Society; Bottom photo: Alycia M. Kunkle)

THE CHATHAM DRAMA GUILD: The other live theater in town, the Chatham Drama Guild, is the second oldest community theater on the Cape. It was established in 1931 and is a nonprofit community theater located on Crowell Road. When it was formed, its current location was the result of bequests, but there was no building on the site. A barn was dismantled board by board and transported to Crowell Road, where it was reassembled in a more appropriate design for a theater. Over the years, the building was enlarged and improved and today is a theater where local talent often provides the cast for a wide variety of presentations. (Top Photo: Chatham Historical Society)

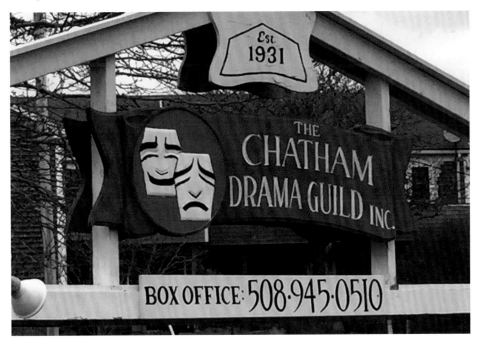

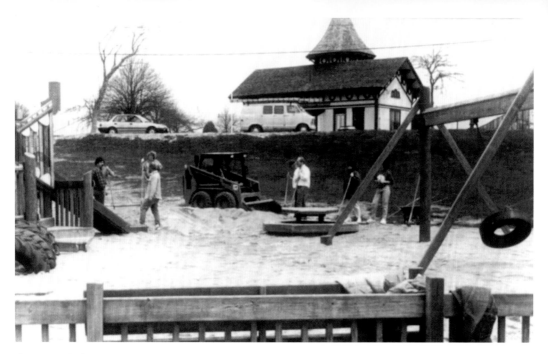

CHATHAM'S CHILDREN'S PLAYGROUND: Located adjacent to Veteran's Field and behind the Chatham Community Center, the playground was first constructed of wood during the late 1900s by volunteers. For many years, school children from the Depot Road School took their recess/recreation times at the park. It was also very popular with children visiting town as well. As it aged, a new design concept was sought for the "Community Tot Lot." The new playground features some custom features for a seaside town. One structure is designed to resemble a ship, another a lighthouse. There is even a ride-on shark and tuna, as well as swings. (Top photo: Chatham Historical Society)

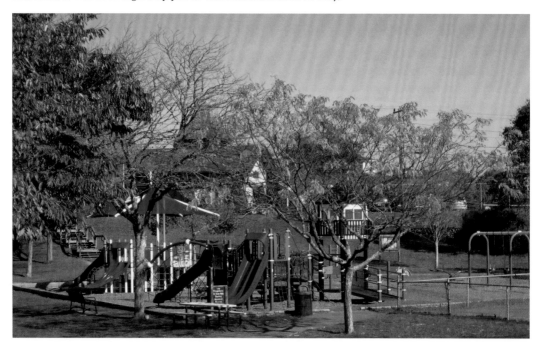

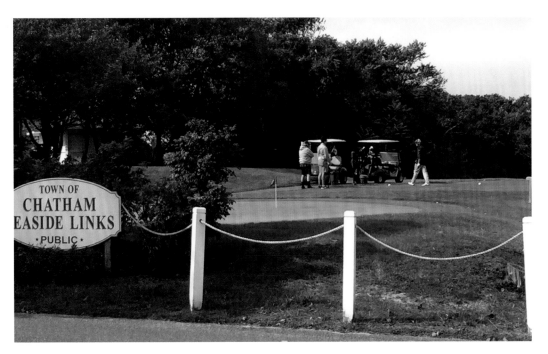

TEE TIME: Playing golf in Chatham is possible at two venues with great scenery. The Town of Chatham Seaside Links is a public course located on both sides of Seaview Avenue adjacent to Chatham Bars Inn. Golfers find the nine-hole golf course, founded in 1895, challenging. Chatham also sports a world-famous members-only golf club. After World War II, a group of men interested in having an 18-hole golf course in Chatham purchased land on Nickerson Neck to build a counterpart of the great seaside links of Scotland and England. By 1924, the hourglass shaped links were opened with a clubhouse at its waist. Today, Eastward Ho! clubhouse has spread across the hillside offering members fine dining and spectacular views.

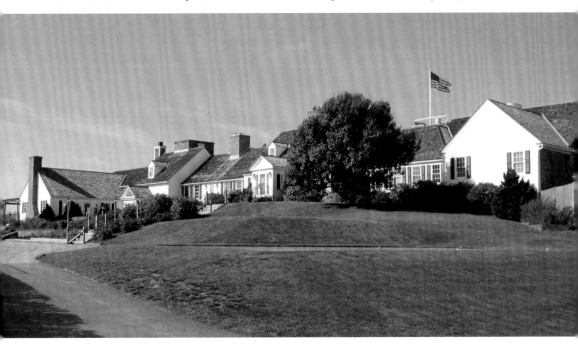

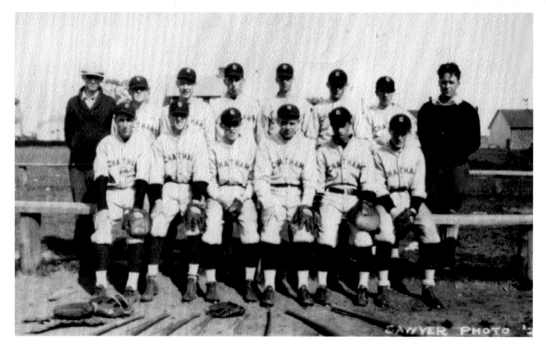

LET'S PLAY BALL: The most popular sport in town has to be baseball. Amateur baseball in Chatham dates back to the early 1900s and the Chatham team was dominant in the Cape Cod Twilight League championships from 1933 to 1939. Chatham baseball teams have played ball at Veteran's Field since 1923. Above is the Chatham Team of 1927. In the 1950s, the fans were sitting very close to the field. The park sits in a bowl, which forms a natural stadium around the field. Its permanent seating capacity today is 2,000; however, much of the seating is informal around the perimeter on grass or lawn chairs, more than tripling the capacity. (Photos: Chatham Historical Society)

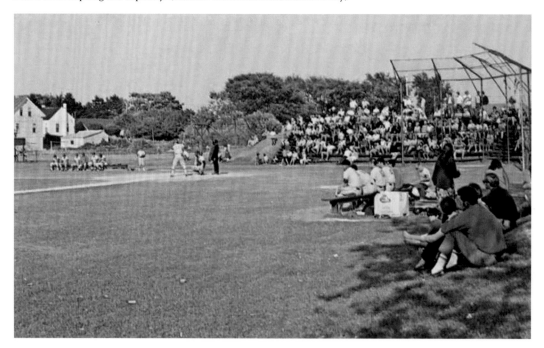

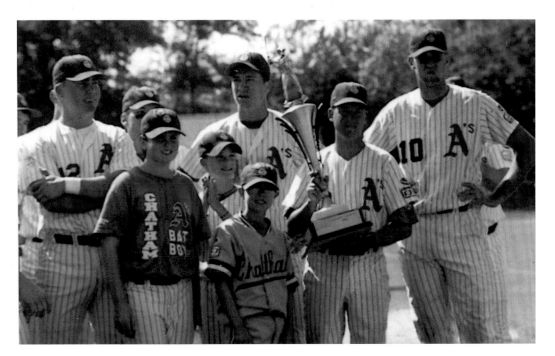

THE CHATHAM ANGLERS: More commonly known as the Chatham A's, the team has been operated by the nonprofit Chatham Athletic Association since 1963. A collegiate summer baseball team, the A's belong to the Eastern Division of the Cape Cod Baseball League of ten teams. The games are a big draw at Veteran's Field, shown below, from mid-June through mid-August. The field house and broadcast booth have been added over the years. The announcers at Veterans Field are college students. Major League baseball scouts visit league games and many players have moved on to the major leagues. (Top photo: Chatham Historical Society; Bottom photo: Scott Lundegren)

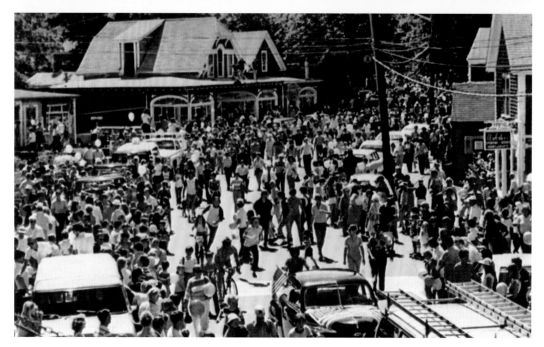

THE FOURTH OF JULY PARADE, A TOWN SPECTACULAR: The first Chatham Fourth of July Parade was in 1908. It's one of the oldest in the country. Now 20,000 spectators crowd into town to see the Chatham Band and others, floats featuring merchants, sports, fishermen, and more recently, seals and sharks. Above, the parade is over and spectators fill the streets. Some years later, the popular Chatham A's carry a banner down Main Street to the applause of the crowds covering Sears Park and environs. The baseball team conducts baseball camps for the community's youth during their summer season and two of the campers help carry the banner. (Photos: Chatham Historical Society)

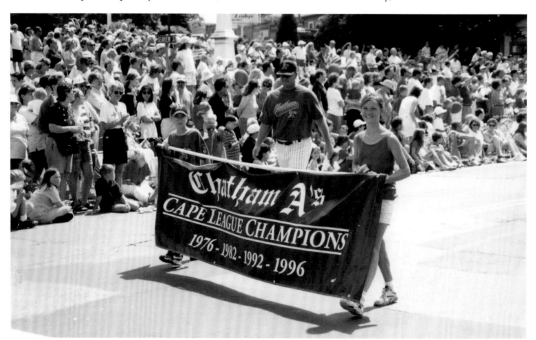

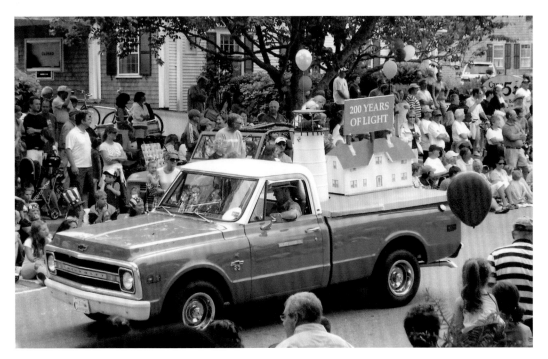

THEMED AND JUDGED: Each year, the Fourth of July Parade Committee decides upon a theme and the entrants use it to inspire their floats. When Chatham celebrated the 200th anniversary of the Chatham Light in 2008, the float above was so themed. Note the lighthouse replica and the two red storm flags designating a hurricane warning in the photo below. The Coast Guard flies these flags when necessary. The woman center front is showing off all her First Night buttons, local collector items. (Photos: Chatham Historical Society)

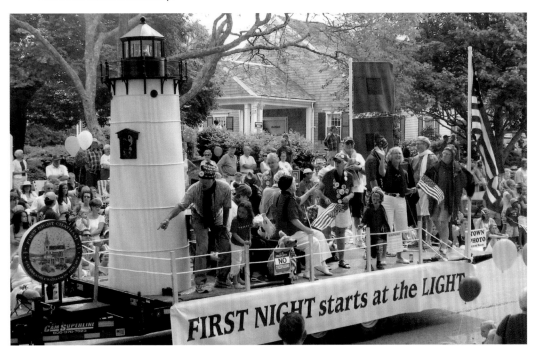

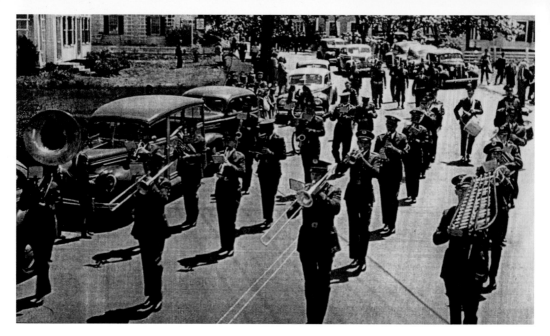

AND THE BAND PLAYS ON: Chatham's Fourth of July Parade is a spectacular each year and is one of the town's major attractions. The Chatham Band's uniforms were adopted prior to World War II and provide color, whether on the bandstand or marching down Main Street on foot (above) or bright sun. The band has also been known to ride down Main Street on a float atop a flatbed truck. Either way, the musicians with their gleaming instruments, red and blue uniforms, and memorable repertoire bring great sound and sights to the annual parade honoring our nation's birthday. (Top photo: Chatham Historical Society; Bottom photo: John Nickerson)

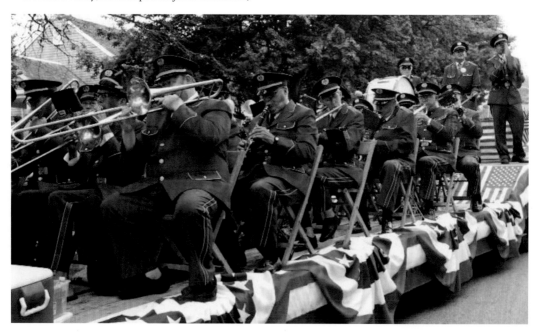

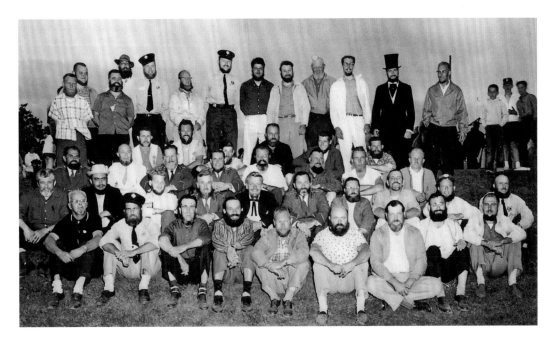

MANDATORY BEARDS: Growing beards on anniversaries seems to be a tradition when Chatham marks its founding anniversaries. Above is a photo from 1962, Chatham's 250th anniversary, when men were required to grow beards or pay a fine. In the back row, the man with the stovepipe hat, resembling Abe Lincoln, is actually Fred Bearse, West Chatham's postmaster. On the 400th anniversary, bearded men and women pose in front of the bandstand in Kate Gould Park and wave to the cameramen. (Top photo: Chatham Historical Society; Bottom photo: *Cape Cod Chronicle*/Tim Wood)

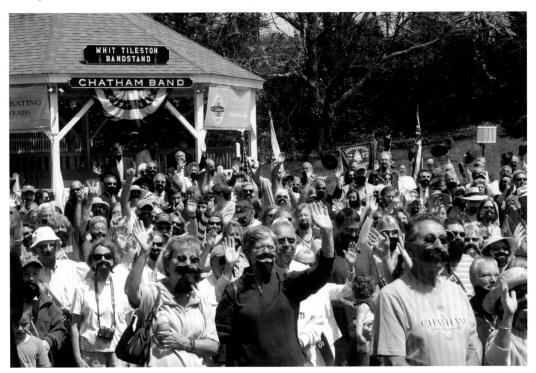

CHATHAM'S FIRST NIGHT:
A town-wide festival of the visual
and performing arts, the event is
family-friendly and alcohol-free
and begins on December 31 at noon.
Lamppost banners proclaim its
imminent arrival. The New Year is
welcomed with fireworks and, since
2007, the Countdown Cod, shown
below with creator Richard Clifford.
One purchases a button to access all
the events. Original founder Marie
Williams came up with the idea and
it was quickly adopted by the town.
The word was announced with a
float in the 1991 July Fourth Parade,
spread by a car in the Harwich
Cranberrry Harvest Festival and a
sign hung from a bridge over Route 6
on Labor Day, inviting visitors back.
(Bottom photo: *Cape Cod Chronicle*/
Alan Pollock)

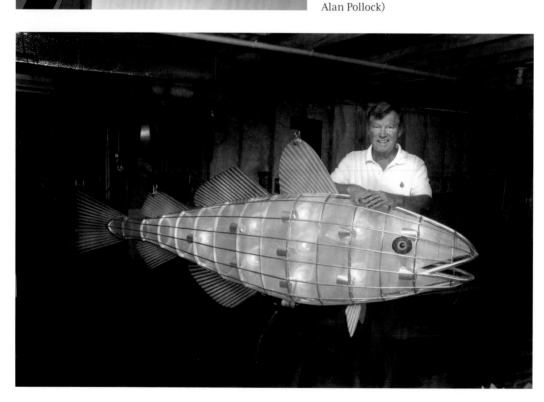

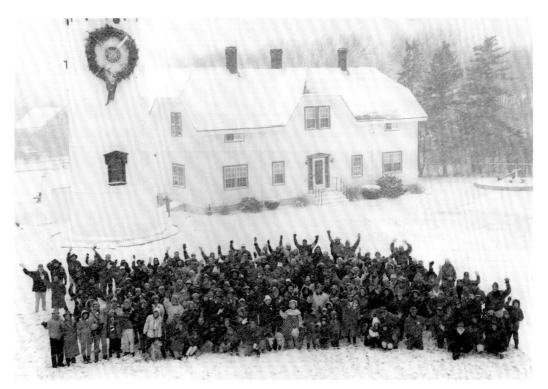

THE TOWN PHOTO: The taking of the town photo has been a First Night Chatham tradition since December 31, 1994. The first photo was taken at Lighthouse Beach, with the photographer looking down at the people, some of whom formed the word Chatham at the front. The next year, and since then, the Town Photo, which kicks off First Night at noon, has been taken at the Chatham Lighthouse. Above is the only Town Photo taken with snow falling. Three other Town Photos do show snow on the ground. Below is the 2015-2016 Town Photo, sort of a family snapshot of people who love this seaside town on the elbow of Cape Cod. (Top photo: First Night Chatham; Bottom photo: Brandon DeTraglia)

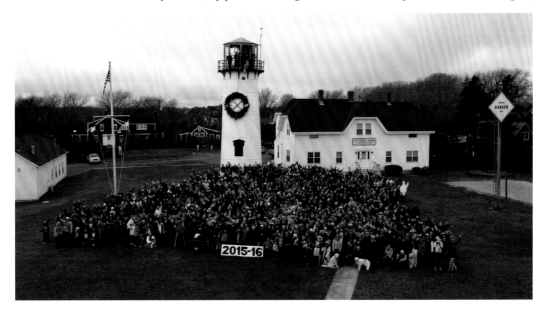

CHATHAM THROUGH TIME

The author wishes to thank the Chatham Historical Society and all those who have been so accommodating in the preparation of this book at its headquarters, the Atwood House Museum.

The presence of such valuable resources as the photographs and postcards used in this book and the archives that offer information on the Town of Chatham, as well as the artifacts in the Atwood House Museum's collections, are a tribute to the generous people of Chatham and the numerous volunteers who spend so much time and thought to maintain the collections and archives.

With the advent of the digital age, one wonders how we will be able to record in visual and written form the history that is emerging today. Our digital cameras, phones, laptops, tablets, and computers might be full of photographs, but will they ever be archived for future generations to see? While the ease of taking photographs is something to be applauded, the ability to erase them is too easy. One wonders how our present will ever make it to the historical archives I have been able to access for this book.

The royalties of this book are being shared with the Chatham Historical Society to help solve the questions I have raised. If you are from Chatham or love Chatham, do support the society to preserve our past, present, and future. You may become a member of the society or donate at *chathamhistoricalsociety.org* to support this treasure.